POSTCARD HISTORY SERIES

Harpers Ferry

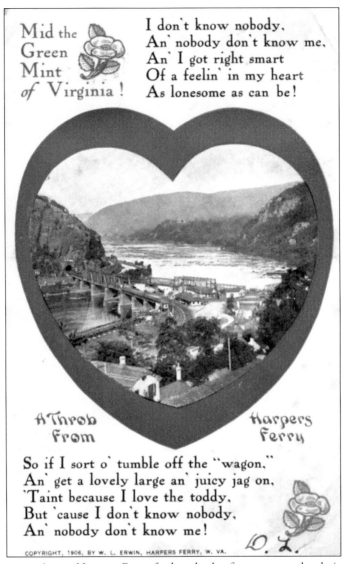

Mid the
Green
Mint
of Virginia !

I don't know nobody,
An' nobody don't know me,
An' I got right smart
Of a feelin' in my heart
As lonesome as can be!

A Throb
From

Harpers
Ferry

So if I sort o' tumble off the "wagon,"
An' get a lovely large an' juicy jag on,
'Taint because I love the toddy,
But 'cause I don't know nobody,
An' nobody don't know me!

COPYRIGHT, 1906, BY W. L. ERWIN, HARPERS FERRY, W. VA.

People have been coming to Harpers Ferry for hundreds of years to soothe their souls and to be soothed and inspired by nature and history and, sometimes, to start anew.

ON THE FRONT COVER: Produced in 1908 by W. L. Erwin as part of his Scenic Souvenirs of Picturesque Historical Harpers Ferry postcard series, this card depicts the battered and weathered Armory Engine House in Harpers Ferry at some point prior to 1891, shortly before its dismantling and shipment to the Chicago Exposition as a tourist attraction. The engine house, known as John Brown's Fort since 1859, has had a strange journey since its original construction in 1847, as is chronicled in chapter five.

ON THE BACK COVER: The town of Harpers Ferry contains many landmarks of national importance, such as the Armory Engine House pictured on the back cover. The Armory Engine House, known as John Brown's Fort, was the location of the capture of John Brown in October 1859. Since that time, the fort has dismantled and rebuilt several times. Since 1968, it rests within 100 yards of its original location in Harpers Ferry.

POSTCARD HISTORY SERIES

Harpers Ferry

James A. Beckman

ARCADIA
PUBLISHING

Published by Arcadia Publishing
Charleston SC, Chicago IL, Portsmouth NH, San Francisco CA

Printed in the United States of America

Library of Congress Catalog Card Number: 2006924193

For all general information contact Arcadia Publishing at:
Telephone 843-853-2070
Fax 843-853-0044
E-mail sales@arcadiapublishing.com
For customer service and orders:
Toll-Free 1-888-313-2665

Visit us on the Internet at www.arcadiapublishing.com

This book is dedicated to all those who have visited and enjoyed the rich history and natural beauty of Harpers Ferry.

Contents

Acknowledgments 6

Introduction 7

1. Views of the Gap and Confluence 9

2. Thomas Jefferson's Visit and Jefferson's Rock 21

3. John Brown's Raid 29

4. Harpers Ferry During the Civil War 45

5. The Story of John Brown's Fort 61

6. Early Street Views and Buildings 69

7. Storer College 97

8. Transportation in Harpers Ferry 105

9. Transition to a National Park 121

ACKNOWLEDGMENTS

As with any book, there are many people behind the scenes who deserve credit for the production of the book and who have worked hard to make it a much better book than if just left to the designs of the author alone. First, while I am grateful to all Arcadia employees who had a hand in improving this book in some fashion or another, I would like to specifically thank two individuals at Arcadia Publishing, Lauren Bobier and Kendra Allen. Ms. Bobier, in charge of Southern Publishing for Arcadia, offered me key early guidance and assistance in commencing this project. Ms. Allen, acquisitions editor for projects concerning West Virginia, also provided very valuable assistance in ensuring that an excellent final product was produced and made key recommendations and revisions along the way. Second, I would like to acknowledge the institutional support of the University of Tampa, which allows its faculty members ample time and resources in which to pursue research and publication topics of value for which the faculty members feel passionate. Third, while all original images in the following pages of this book come from my personal collection acquired over the years, I would not have been able to amass such a diverse collection of images regarding the town without my wife's great indulgences in allowing me to acquire such images at auctions, estate sales, and other places during the last decade. More importantly, however, I am grateful for her constant support, love, and goodwill during the last decade and a half of our journey together through life, much of it happily spent in Harpers Ferry. Finally, I cherish the fond memories of close, dearly departed family members who have visited us in Harpers Ferry—including Joseph Koczwara, Robert C. Beckman, and Robert F. Geil—who have themselves become part of the history of the town through their visits and part of the long list of Americans who have sojourned to Harpers Ferry over the last several centuries to enjoy its rich history and natural beauty.

INTRODUCTION

Harpers Ferry has been a famous tourist attraction since the very earliest days of the Republic—situated at the confluence of two great rivers, the Shenandoah and the Potomac, surrounded by formidable rocky and mountainous terrain, and guarded by the twin rocky sentinels of Maryland and Loudoun Heights. Indeed, Thomas Jefferson visited the town on October 25, 1783, and climbed up to a large rock formation on the heights above the fledgling town. He was so inspired by the view from these rocks that he wrote for posterity about the town's beauty in his book *Notes on the State of Virginia*, commenting that the town provided "a scene . . . worth a voyage across the Atlantic." Many settlers soon took Jefferson's advice to visit the town, and the small hamlet began to thrive.

George Washington visited the town as well and noted its strategic importance to the new republic, and it was he who established the federal Armory at Harpers Ferry in 1796. The Armory provided the nation with much of its rifles and firearms prior to the Civil War. The Armory also outfitted the Lewis and Clark expedition, and Meriwether Lewis spent several weeks in Harpers Ferry testing out equipment before making his famous journey across the continent. The town was also an important early stop along both the Chesapeake and Ohio (C&O) Canal and the Baltimore and Ohio (B&O) Railroad—both connected to the town by the 1830s—and many industrial "firsts" took place at the Armory and in the town in the early 19th century.

Of course, Harpers Ferry played a prominent role in the start of the Civil War. In 1859, John Brown and a band of 21 men seized the town and the federal arsenal in an attempt to overthrow the institution of slavery by force. After several days and much bloodshed, John Brown was captured by a company of approximately 90 U.S. Marines, commanded by Lt. Col. Robert E. Lee and assisted by a young lieutenant, J. E. B. Stuart. After a trial that captivated the nation, Brown was executed on December 2, 1859. At his execution, notable individuals were present, such as Stonewall Jackson and John Wilkes Booth. In a speech at Harpers Ferry 22 years after the raid and 16 years after the conclusion of the Civil War, Frederick Douglass commented that "if John Brown did not end the war that ended slavery [at Harpers Ferry], he did, at least, begin the war that ended slavery. . . . John Brown began the war that ended American slavery, and made this a free republic." When the war followed within a year and half after Brown's raid, the town of Harpers Ferry was a strategic and sought-after prize between the North and the South, and it was occupied many times by both sides during the war.

Also after the Civil War, Storer College, one of the first institutions of higher education for blacks in the South, was established at Harpers Ferry in 1867. Frederick Douglass served as a trustee member for the college, and W. E. B. Du Bois and other famous African Americans

visited the campus. Needless to say, Storer College played a very important role in the town from 1867 to 1955, and many of the college campus buildings are still extant today.

The town also has been said to be the best example of intact 19th-century antebellum architecture in the United States. The National Park Service maintains the appearance of much of the town as it looked and existed in 1859, the year of John Brown's raid. As such, virtually all of the buildings in the center of town ("the lower town") were built prior to the Civil War. Additionally, of all of the privately owned buildings outside of the National Park Service boundaries, it is said that a great majority of those are antebellum structures as well.

Given the town's richness and depth, it should come as no surprise that a plethora of early vintage postcards from the town were made commencing in the 1880s. Many old vintage postcards celebrate the views of this famous town, from Jefferson's Rock to the confluence of the Shenandoah and Potomac Rivers, to spots in town associated with John Brown's raid and the occupancy of troops during the Civil War, to places of worship, commercial activities, and residences.

Over the years, the village has inspired fascination and enchantment in multiple generations of people who visited the town, including many writers and poets, such as Nathaniel Hawthorne, Mark Twain, and Carl Sandburg, just to name a few. Carl Sandburg aptly called the town "a meeting place of winds and water, rocks and ranges." Yet the history does not involve one individual or event but multiple individuals—black and white, men and women, old and young—and events woven through the fabric of time. During its entire history and up through today, Harpers Ferry has been a functioning town, where people are born, live, work, play, and sometimes die. The fact that so many famous Americans have passed through the town only enriches the town's history and aura. The history of Harpers Ferry is America's history—to be treasured and enjoyed by all who visit.

One

Views of the Gap and Confluence

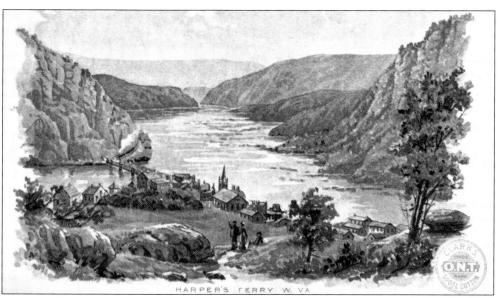

HARPER'S FERRY W. VA.

First aptly known as "The Hole" among early occupants and visitors, the village was dwarfed by the surrounding rocky heights and appeared from several miles off to travelers as "a hole" or geological depression amidst the formidable mountainous terrain. The area was first settled by a fur trader, Peter Stephens, who first squatted on the land in 1733. In 1747, the land was purchased by town founder Robert Harper. In 1763, the Virginia General Assembly incorporated the village as "Shenandoah Falls at Mr. Harper's Ferry," in reference to Mr. Harper's ferry service across the Shenandoah River. Prior to the advent of the postcard era, scenic vistas and town views were often depicted in wood carvings in newspapers and through commercial advertisements. This town view appeared on a Victorian-era advertisement for Clark's O. N. T. Spool Cotton for hand and sewing machines.

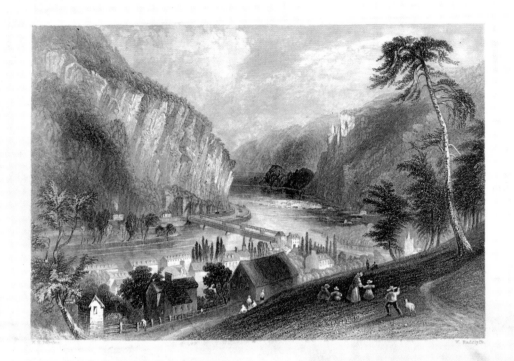

HARPERS FERRY.

(From the Potomac side.)

By the 1830s, Harpers Ferry was a thriving industrial village, with the southern armory producing approximately 10,000 stacks of arms per year for the federal government, and both the B&O Railroad and the C&O Canal reaching the town in the mid-1830s, allowing for the massive influx of individuals and commerce. The above engraving completed in 1839 by William Henry Bartlett depicts the town during this period of prosperity. Bartlett, a British citizen, toured America from 1839 to 1842 and drew images of American cities and scenery, which were engraved onto steel prints (like above) and also included in his book published in London in 1840 entitled *American Scenery*. However, a dim view of the "progress" of Harpers Ferry was delineated in the book, as the author explained that "the unpicturesque new village of the white man, his mill, or his factory, does not convey to my imagination an image of happiness; and I regret the primitive rover of the wild, who neither blackened nature with smoke, nor violated her harmony with brick and shingle."

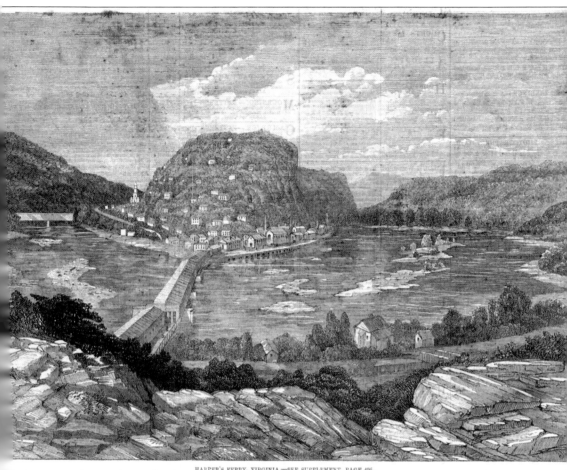

HARPER'S FERRY, VIRGINIA,—SEE SUPPLEMENT, PAGE 496.

Prior to the mass production of postcards and tourism brochures, town views often appeared in a variety of local, national, and international newspapers. When this illustration depicting the town of Harpers Ferry was published across the front page of *The Illustrated London News* in May 1861, Londoners could see from the comfort of their own homes the town and view that Thomas Jefferson declared was "a scene . . . worth a voyage across the Atlantic"—even without making the voyage. Note the covered wooden bridge in the foreground. It is this bridge that insurrectionist John Brown crossed with his raiders in the early morning hours of October 17, 1859. The bridge was destroyed within a few months of the publication of this paper by Confederate forces, and the bridge would be rebuilt and destroyed multiple times during the Civil War.

Bird's-eye view of Harpers Ferry and Bolivar Heights
above the confluence of the Poto...

This panoramic postcard published by W. L. Erwin in 1908 shows tourists from the 1880s enjoying a view of the town from the summit of Loudoun Heights. The view from this vantage point had long been enjoyed by visitors to the town. In a tourist book published in 1809 and entitled *A Tour through Part of Virginia in the Summer of 1808*, the author (John Edwards Caldwell) comments that while the roads leading to Harpers Ferry are "miserably bad, . . . the country

, from a lofty Virginia eminence
Shenandoah

[is] beautiful and the land good; the approach to the ferry is strikingly picturesque, and after crossing, ascending the hill, and viewing the junction of the Shenandoah and the Potowmack . . . the mind is lost in wonder and admiration, and my pen in vain attempts a description of the scene itself, or the feelings I experienced in contemplating this great work of nature!"

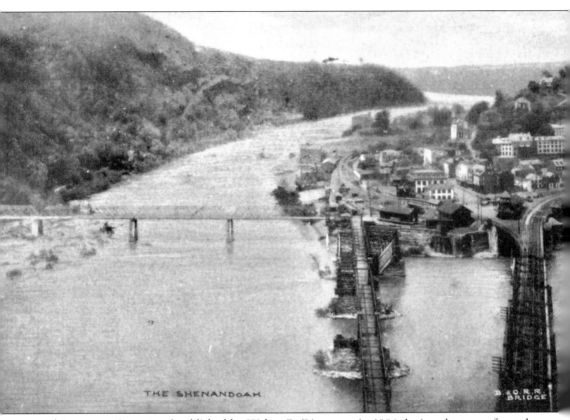

THE SHENANDOAH

B. & O. R.R.
BRIDGE

This panoramic postcard published by Walter E. Dittmeyer in 1906 depicts the town from the summit of Maryland Heights, along with the bridges that traversed the Potomac and Shenandoah Rivers. At the bottom left corner of this card, the Shenandoah and Potomac Rivers meet and flow onwards to Washington, D.C., and to the sea. The ill-fated Shenandoah Bridge is depicted

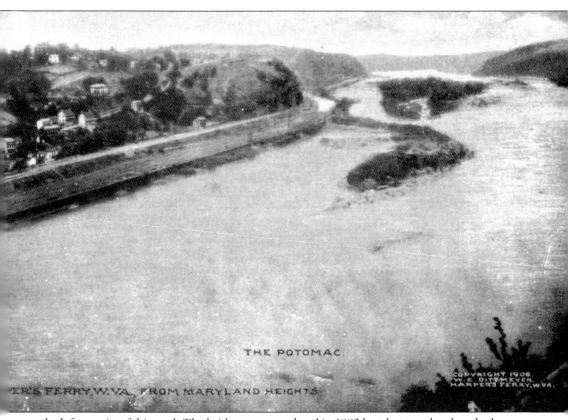

THE POTOMAC.

PER'S FERRY, W.VA. FROM MARYLAND HEIGHTS.

COPYRIGHT 1906.
W. E. DITTMEYER,
HARPERS FERRY, W.VA.

at the left margin of this card. The bridge was completed in 1882 but destroyed and washed away by floodwaters in 1889, a mere seven years after construction. This card also nicely depicts the "lower town" of Harpers Ferry (middle of the card) in its relation to the Camp Hill and the "upper town" (top middle of the card).

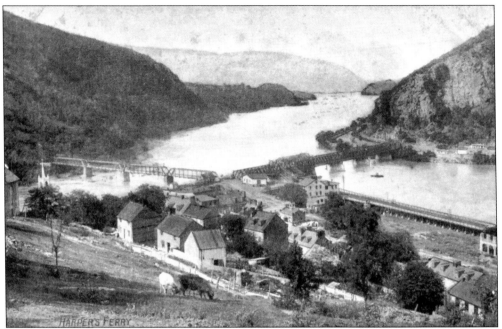

In this postcard dated 1909, lower town is depicted in a bucolic postwar setting, complete with cows roaming the neighborhood. Note that the view of the "gap" is backwards on this card. The Shenandoah River is incorrectly pictured from the left center and the Potomac River is depicted on the right center of the card.

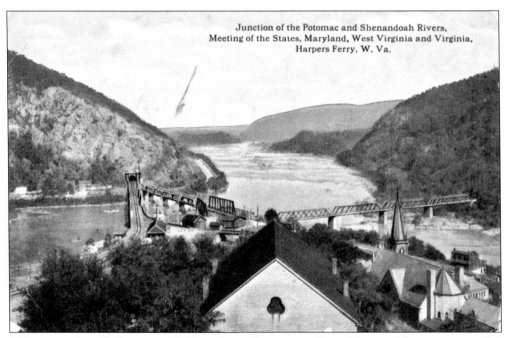

This postcard, mailed on May 19, 1913, shows the correct view of the gap. If one compares this card with the previous card, one can see the reversal error on the previous card by comparing the position of the bridges and the C&O Canal.

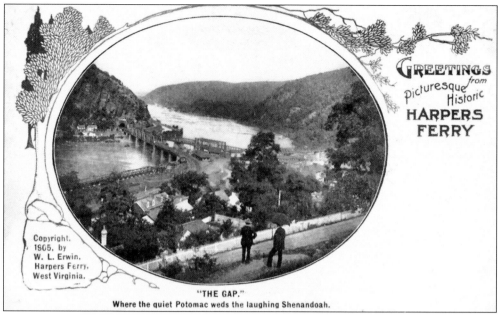

"THE GAP."
Where the quiet Potomac weds the laughing Shenandoah.

The card caption describes the confluence as "where the quiet Potomac weds the laughing Shenandoah." This card is part of W. L. Erwin's series Greetings from Picturesque Historical Harpers Ferry, of which approximately 30 different c. 1900 views are depicted. Many of the early postcards of Harpers Ferry were made by either W. L. Erwin or Harpers Ferry pharmacist Walter E. Dittmeyer.

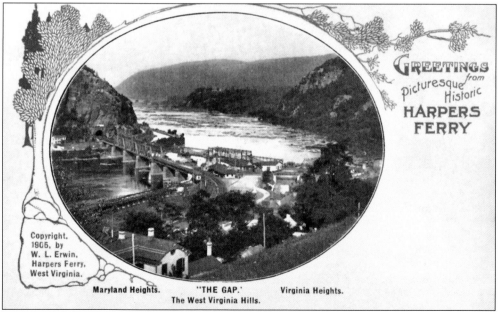

Maryland Heights. "THE GAP.' Virginia Heights.
The West Virginia Hills.

The caption on this card orients the viewer to the various rocky heights surrounding the town. Across the Potomac is Maryland Heights. On the right side of this card, across the Shenandoah, is Virginia Heights, now known as Loudoun Heights. Finally, this card is taken from a hill overlooking lower town and connecting lower town with the upper town, Camp Hill, and Bolivar—which is simply described as "The West Virginia Hills" on the card.

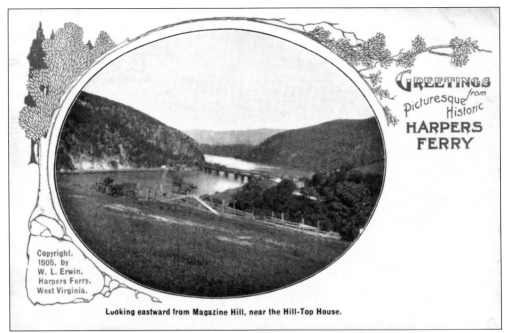

Looking eastward from Magazine Hill, near the Hill-Top House.

The vantage of this image showing the confluence and gap is taken approximately from the location of the present-day Hilltop Hotel. The card caption describes the location as "Magazine Hill," an early name for this area of town, referencing where stacks of arms were stored after being manufactured by the U.S. Armory in the town below.

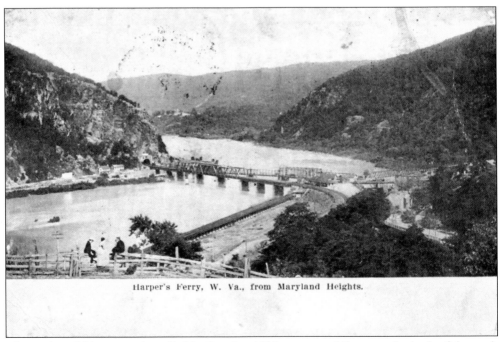

Harper's Ferry, W. Va., from Maryland Heights.

The sender of this postcard, mailed in October 1909, wrote as follows on the back of the card: "I hunted all along the top of the mountain in the distance. Do you see the people sitting on the fence? Well that is not me."

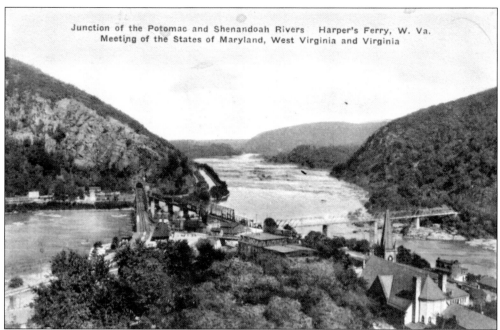

Junction of the Potomac and Shenandoah Rivers Harper's Ferry, W. Va.
Meeting of the States of Maryland, West Virginia and Virginia

Taken from the Camp Hill section of Harpers Ferry, this Dittmeyer postcard of the gap and confluence also shows two prominent buildings jutting out of the tree line in the town below. Most notably, the church depicted at the bottom right of the card is the historical St. Peter's Church. The building in the middle of the card (to the left of St. Peter's Church) is the Hotel Conner, which as one of the town's hotels advertised itself as the "headquarters for traveling men" and also offered a popular watering hole, the Hotel Conner Bar.

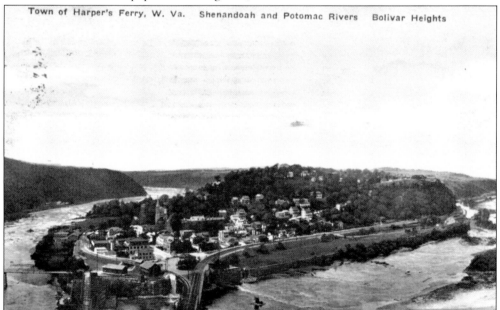

Town of Harper's Ferry, W. Va. Shenandoah and Potomac Rivers Bolivar Heights

This Dittmeyer postcard depicts Harpers Ferry from the vantage point of the cliffs of Maryland Heights. Beyond the Harpers Ferry town limits is the adjacent village of Bolivar. Bolivar Heights is pictured on the ridgeline off in the distance on this card.

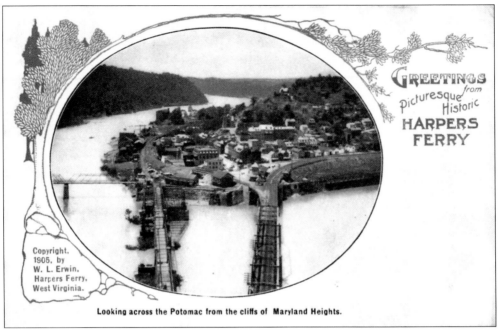

Copyright,
1905, by
W. L. Erwin,
Harpers Ferry,
West Virginia.

Looking across the Potomac from the cliffs of Maryland Heights.

This Erwin postcard also shows the specific view of lower town from the vantage point of Maryland Heights. The view is largely the same today, except that only one of these three bridges (the one to the far right) still stands and a few less structures are now standing in town.

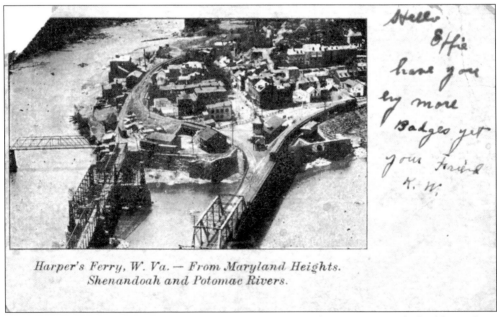

Harper's Ferry, W. Va. — From Maryland Heights.
Shenandoah and Potomac Rivers.

This postcard depicts a more in-depth view of lower town in the 1880s. Note the buildings along the banks of the Shenandoah River. These residences and businesses were all eventually destroyed by a series of floods that laid waste to the town over the years. Today only the foundations of several of these buildings are visible to visitors.

Two

THOMAS JEFFERSON'S VISIT AND JEFFERSON'S ROCK

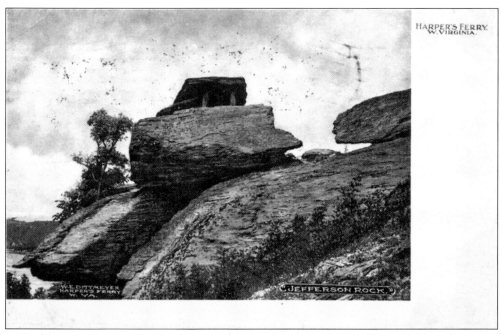

One of the prominent geological features of the town is the existence of a unique rock formation on the heights of the town, overlooking the town and the confluence of the Shenandoah and Potomac Rivers. The rock formation attracted sightseers as far back as the 1780s, and townspeople and visitors alike would carve their names or initials into the rock. Over time, the rock formation became one of the leading landmarks in town, in part based upon a very early visit in 1783 by a prominent Virginian and future president of the United States, as well as the author of America's Declaration of Independence.

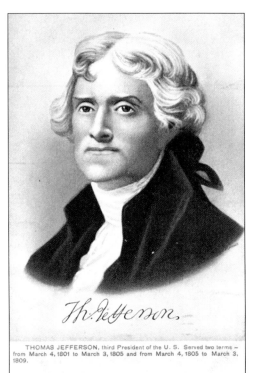

THOMAS JEFFERSON, third President of the U. S. Served two terms — from March 4, 1801 to March 3, 1805 and from March 4, 1805 to March 3, 1809.

On October 25, 1783, future president of the United States Thomas Jefferson visited Harpers Ferry. Jefferson, no stranger to the natural beauty that abounded within the colony of Virginia, was nonetheless startled by the view from atop this rock formation and therefore memorialized his description of the scene in his subsequent book *Notes on the State of Virginia.*

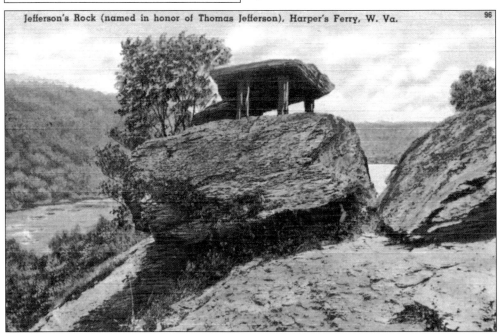

Jefferson's Rock (named in honor of Thomas Jefferson), Harper's Ferry, W. Va. 96

Jefferson stood on the rock and wrote: "You stand on a very high point of land; on your right comes up the Shenandoah, having ranged along the foot of the mountains a hundred miles to find a vent; on your left approaches the Potomac, in quest of a passage also. In the moment of their junction, they push together against the mountain, rend it asunder, and pass off to the sea. The scene is worth a voyage across the Atlantic."

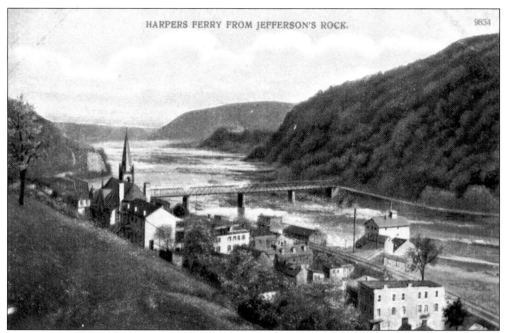

After Jefferson's visit in October 1783, residents took to calling the site Jefferson's Rock. This postcard captures the view of the town from Jefferson's Rock, looking down the Potomac River and showing many of the residences and businesses along Shenandoah Street.

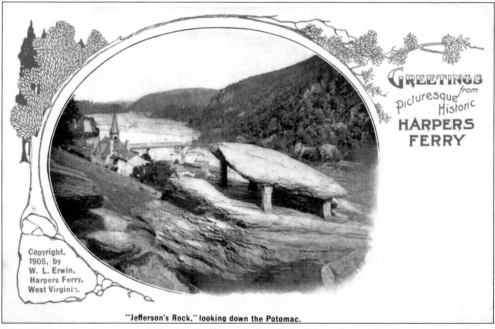

Greetings *from* picturesque Historic **HARPERS FERRY**

Copyright, 1905, by W. L. Erwin, Harpers Ferry, West Virginia.

"Jefferson's Rock." looking down the Potomac.

This W. L. Erwin postcard depicts Jefferson's Rock looking down the Potomac, with the confluence of the Shenandoah and Potomac Rivers in the distance beyond the steeple of St. Peter's Church, as the Potomac, in the words of Jefferson, rushes onward "to the sea." Note the C&O Canal in the distance and across the Potomac River from Harpers Ferry.

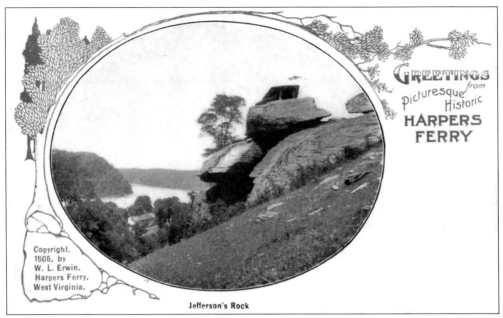

Jefferson's Rock

To the left front of the foundational rock upon which Jefferson's Rock rests, one can make out three houses on Virginius Island. Virginius Island was situated along the Shenandoah River upriver from Harpers Ferry and contained many of the industries and businesses of Harpers Ferry in the 19th century. The row houses depicted here likely belonged to those who also worked in the factories on Virginius Island.

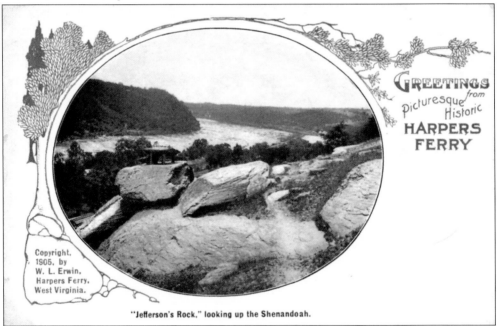

"Jefferson's Rock," looking up the Shenandoah.

This postcard from the W. L. Erwin series shows Jefferson's Rock amidst the backdrop of the Shenandoah River upriver from Harpers Ferry and the northern part of the Shenandoah Valley. Note again the residences to the right of Jefferson's Rock in the far off-distance below on Virginius Island.

24

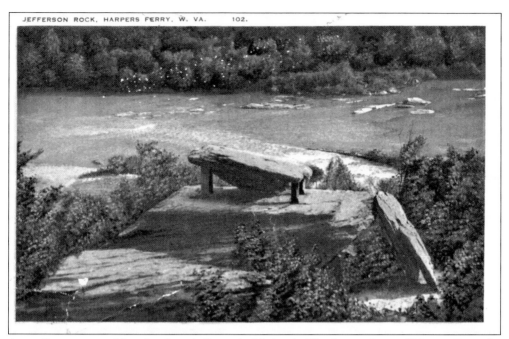

According to town historian Joseph Barry in his book *The Strange Story of Harpers Ferry*, the uppermost rock rested naturally on its rock foundation, which was "so narrow that it might easily be made to sway back and forth by a child's hand." However, according to Barry, "the original foundation . . . dwindled to very unsafe dimensions by the action of the weather, and still more, by the devastation of tourists and curiosity-hunters."

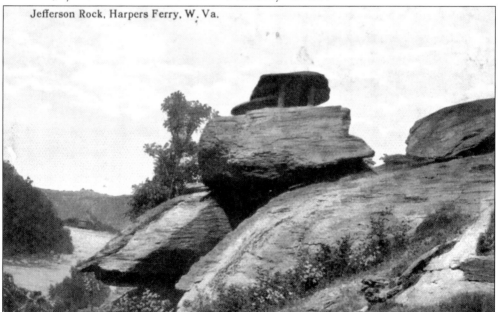

Jefferson Rock, Harpers Ferry, W. Va.

Given its instability, at some point between 1855 and 1860, the superintendent of the U.S. Armory ordered Seneca red sandstone pillars placed beneath the rock because the rock was "endangering the lives and properties of the villagers below." Houses on Shenandoah Street were immediately below Jefferson's Rock and endangered by it.

25

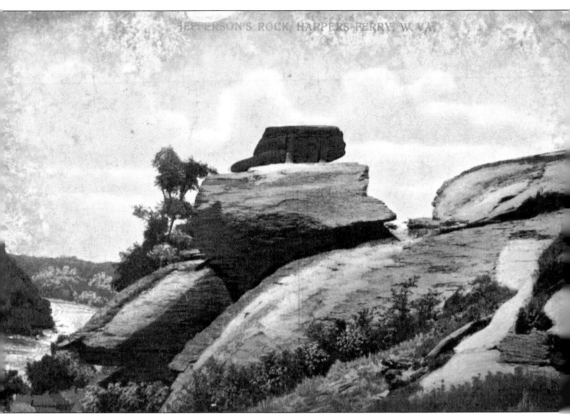

After visiting Harpers Ferry on May 24, 1834, Pres. John Quincy Adams took issue with Jefferson's description in his diary, writing that "we then ascended the Hill, which overlooks the village . . . [and] here we saw the junction of the Potomac and Shenandoah Rivers, described somewhat enthusiastically by Mr. Jefferson. . . . There is not much of the sublime in the Scene, and those who first see it after reading Mr. Jefferson's description are usually disappointed." Also, in a story recounted by town historian Joseph Barry, opponents of Jefferson tried to deface the landmark in 1799. One Federalist-minded captain was "said to have taken his company, one day, to Jefferson's Rock and ordered them to overthrow the favorite seat of Jefferson, his political enemy." Again according to Barry, "they succeeded in detaching a large boulder from the top which rolled down hill to Shenandoah street, where it lay for many years, a monument to stupid bigotry."

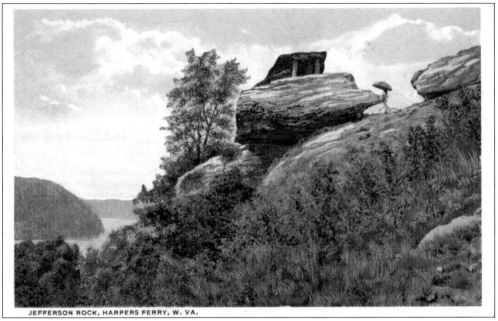

JEFFERSON ROCK, HARPERS FERRY, W. VA.

Jefferson's Rock remained undamaged even during the Civil War. Thousands of soldiers visited the landmark when passing through town, and many stopped to carve their names in the rock—carvings that are still largely visible today. Note the female visitor with the umbrella to the right of Jefferson's Rock in this postcard.

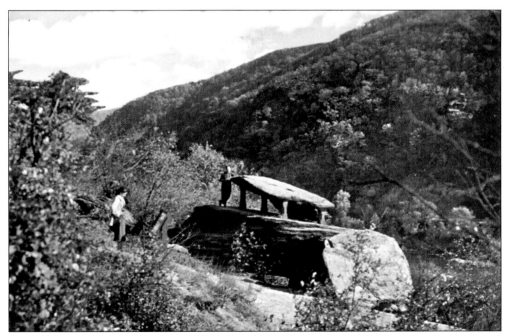

In April 1998, Pres. Bill Clinton and Vice President Al Gore visited Harpers Ferry and planted wildflowers at the base of Jefferson's Rock. President Clinton's visit marked a long history of sitting presidents visiting Harpers Ferry, including Presidents George Washington, John Adams, Thomas Jefferson, John Quincy Adams, Abraham Lincoln, Woodrow Wilson, and Jimmy Carter.

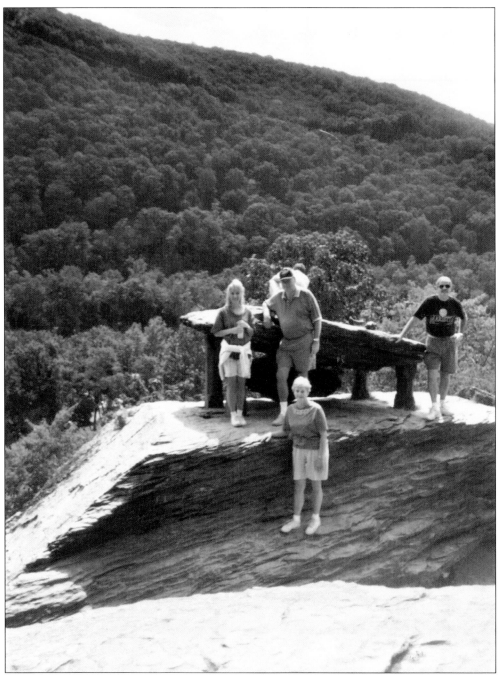

In 2004, Jefferson's Rock was vandalized by several teenagers who coated the entire rock in white paint. While the park service was able to remove the paint with minimal damage to the rock, climbing or walking on Jefferson's Rock is now prohibited. Millions of visitors still flock from all over the world to see Jefferson's Rock, and prior to 2004, to stand on the rock where Thomas Jefferson once viewed the landscape and declared it worth a "voyage across the Atlantic" to see. Here, in October 1997, visitors from Ohio (Robert [middle] and Jean Beckman [bottom]) pose for a photograph atop Jefferson's Rock with local resident Maria Beckman (left).

Three

JOHN BROWN'S RAID

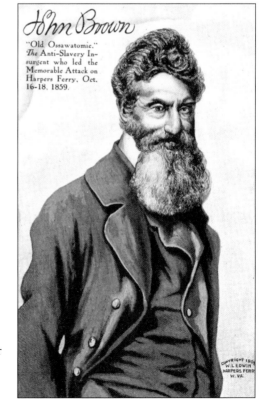

In 1859, John Brown's raid on the town would forever intertwine the history of the town with that of America and the Civil War. In the words of Frederick Douglass, "if John Brown did not end the war that ended slavery, he did, at least, begin the war that ended slavery. . . . John Brown began the war the ended American slavery, and made this a free republic." John Brown began this war at Harpers Ferry.

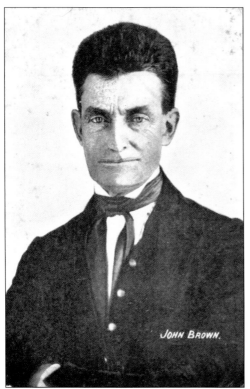

John Brown spent much of his life in a variety of failed business attempts and trying desperately to support his family of 20 children. He drifted through several states before reaching Harpers Ferry, including Connecticut, Ohio, Pennsylvania, Massachusetts, New York, Maryland, and Kansas. While he was involved in the Underground Railroad, his more radical actions as an abolitionist did not occur until the last five years of his life.

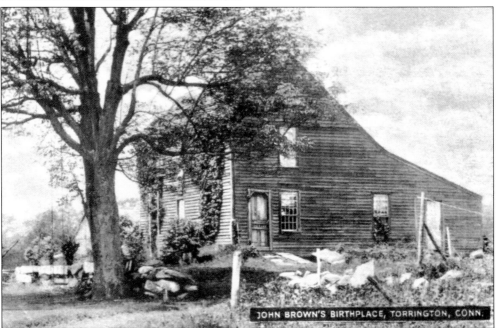

John Brown was born on May 9, 1800, in Torrington, Connecticut, only a few miles away from the home of Harriet Beecher Stowe. Stowe, the author of *Uncle Tom's Cabin*, is considered, like Brown, a contributing factor/cause of the Civil War. The home depicted here was destroyed by fire in 1918, and only part of the foundation and a historical marker are visible on the site today.

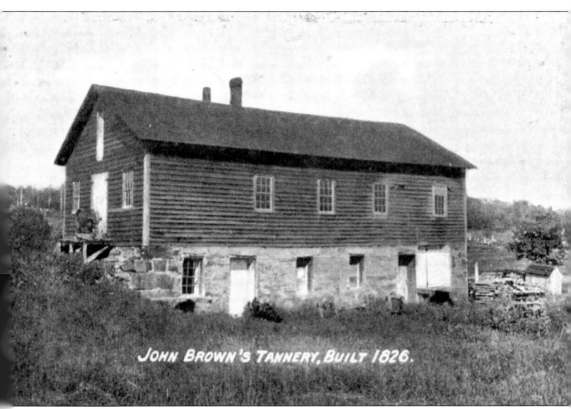

JOHN BROWN'S TANNERY, BUILT 1826.

In 1810, John Brown's father moved the family to Ohio, where John Brown would live until 1825. John Brown then moved to New Richmond, Pennsylvania, and built a tannery. This tannery employed as many as 15 workers, and Brown ran the tannery from 1825 to 1835, as well as serving as a postman for the town for seven years. He also built a school for the children of the town. The foundation of this building still exists and is designated by a historical marker that was dedicated by the State of Pennsylvania on November 18, 1946, and remains visible today. This tannery represents a time in John Brown's life when he was a successful and respected business leader. Two years after his departure, in 1837, Brown arose from the back of a church in Hudson, Ohio, and proclaimed that "here, before God, in the presence of these witnesses, I consecrate my life to the destruction of slavery."

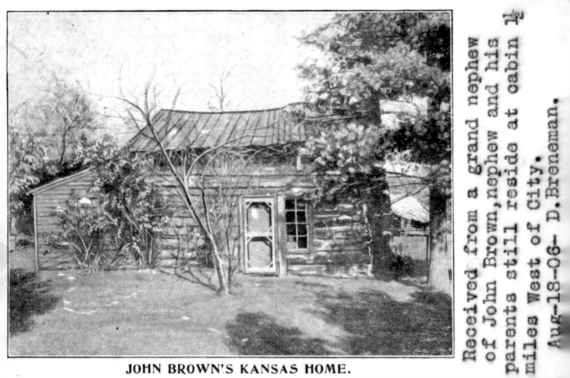

JOHN BROWN'S KANSAS HOME.

Received from a grand nephew of John Brown, nephew and his parents still reside at cabin 1½ miles West of City. Aug–18–06– D.Breneman.

For the next 20 years, from 1835 to 1855, Brown spent time in a variety of failed business ventures in Ohio, Pennsylvania, and New York. Then, in 1855, Brown joined five of his sons (Jason, Frederick, Salmon, Owen, and John Jr.) in "Bleeding Kansas," fighting as abolitionists against the pro-slavery forces and "Border Ruffians." In May 1856, Brown gained national notoriety when he led a band of men into a pro-slavery settlement along the Pottawatomie Creek in Osawatomie, Kansas, where five pro-slavery settlers were massacred by Brown's band. After this point, Brown became known as "Old Osawatomie" or "Osawatomie Brown" in reference to these killings. Brown also formulated his Harpers Ferry plan at this time. This postcard depicts John Brown's home with the message that the card was "received from a grand nephew of John Brown, nephew and his parents still reside at cabin 1 1/2 miles West of City." The postcard is postmarked Osawatomie, Kansas, and is dated August 18, 1906. Note the child in the front window—perhaps a relative of John Brown.

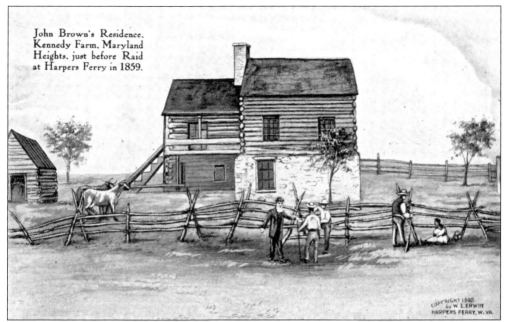

John Brown's Residence, Kennedy Farm, Maryland Heights, just before Raid at Harpers Ferry in 1859.

COPYRIGHT 1908
by W. L. ERWIN
HARPERS FERRY, W. VA.

John Brown arrived in Harpers Ferry on July 3, 1859, and, after introducing himself as Isaac Smith, inquired about good farmland to rent in the area. He was informed of the Kennedy farm, located about five miles north of Harpers Ferry. Brown rented this property for $35 in gold and made the Kennedy farmhouse the base of his operations and staging area for his raid on Harpers Ferry in October 1859.

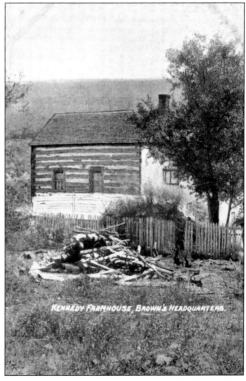

KENNEDY FARMHOUSE, BROWN'S HEADQUARTERS.

From July to October 1859, Brown waited at the farm for the arrival of men and weapons—both of which trickled in during the summer and autumn. The farmhouse consisted of a basement cellar, a parlor and bedrooms on the first floor, and an attic. The attic was used to keep all the raiders out of sight during the day. There was also a small cabin that was used as sleeping quarters and storage.

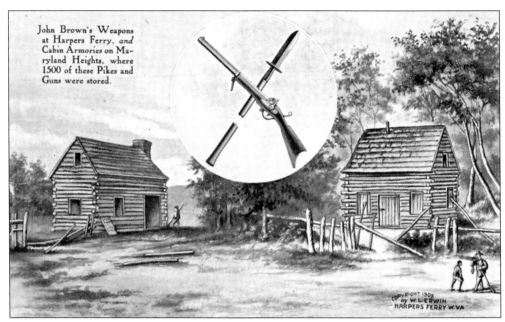

John Brown's Weapons at Harpers Ferry, and Cabin Armories on Maryland Heights, where 1500 of these Pikes and Guns were stored.

Leading up to Brown's raid, a massive amount of arms was accumulated, including 200 new Sharps rifles, 1,000 pikes (to arm the slaves), and a large number of pistols. The weapons were shipped from Ohio to Chambersburg, Pennsylvania, in wooden crates marked "Hardware and Castings." At Chambersburg, one of the raiders (John Kagi) sent the weapons by wagon to Brown at Harpers Ferry, where the weapons were stored in the old wooden schoolhouse depicted here.

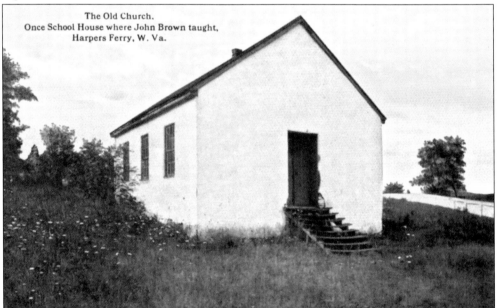

The Old Church.
Once School House where John Brown taught,
Harpers Ferry, W. Va.

While most of Brown's men were required to hide out at the Kennedy farmhouse and only go outside after dark, John Brown (disguised as Isaac Smith) did go out into the community on several occasions. He even gave a sermon at the local church, pictured here, only a week prior to his raid on the town.

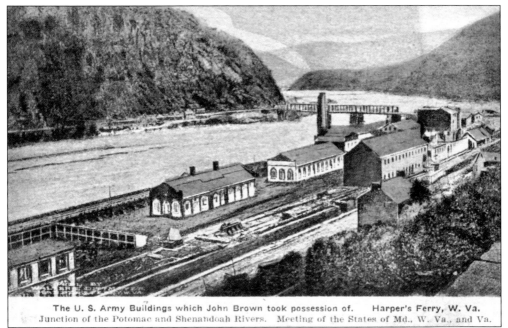

The U. S. Army Buildings which John Brown took possession of.　Harper's Ferry, W. Va.
Junction of the Potomac and Shenandoah Rivers.　Meeting of the States of Md., W. Va., and Va.

Brown's plan was to strike at the institution of slavery and foment slave revolts throughout the South. Brown selected Harpers Ferry as the target for his attacks because it was a part of one of the most prosperous and well known of the Southern slave states (Virginia), it was the location of the federal arsenal, and it was in proximity to mountainous terrain that could be used for retreat and as a base of future operations.

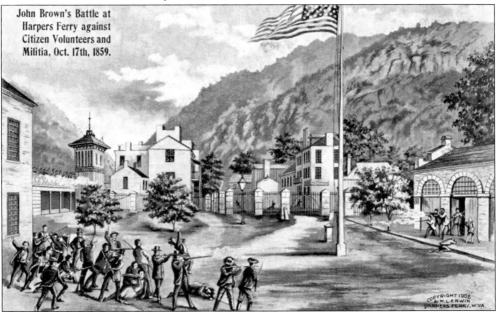

John Brown's Battle at Harpers Ferry against Citizen Volunteers and Militia, Oct. 17th, 1859.

Brown and his band of men took over the town and the federal arsenal on October 16–17, 1859, but were ultimately beaten back to the engine house by several local militias, at which time a standoff ensued. The initial battle between the local militia and John Brown's men is depicted in this 1908 postcard.

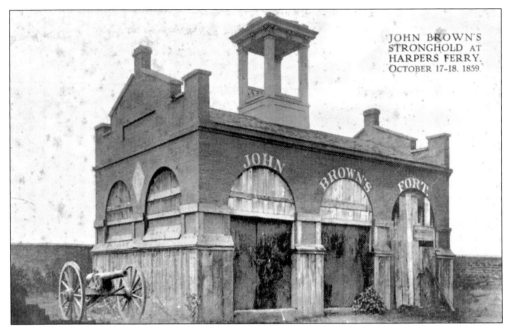

By midday on October 17, Brown and his remaining men had retreated to the Armory Engine House under fire from the townspeople and local militias. Before the arrival of the militia, Brown could have forced his way out of the town. However, once the militia arrived, Brown's position became as Frederick Douglass had predicted several months before, "a perfect steel trap" from which "he would never get out alive."

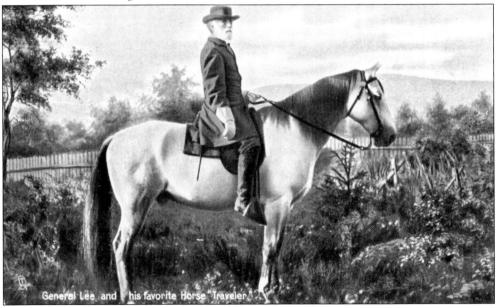

General Lee and his favorite Horse "Traveler"

On October 17 at about 11 p.m., approximately 90 U.S. Marines arrived at Harpers Ferry, having been ordered up from Washington, D.C., by Pres. James Buchanan. Lt. Col. Robert E. Lee, at his home at Arlington, was ordered by President Buchanan to take command of the Marines. This early postcard of Lee and his horse, Traveller, was commissioned by Lee in 1868, stating "I don't want a picture of myself, but of my faithful animal."

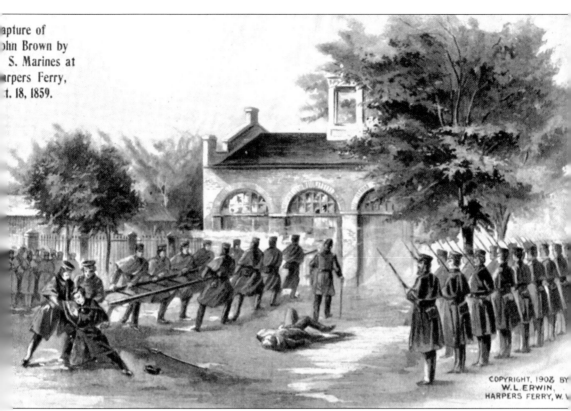

apture of
hn Brown by
S. Marines at
rpers Ferry,
t. 18, 1859.

COPYRIGHT, 1908 BY
W. L. ERWIN,
HARPERS FERRY, W. V

Upon Lee's arrival in Harpers Ferry, he was inclined to order an immediate attack on Brown, "but for the fear of sacrificing the lives of some of the gentlemen held . . . as prisoners." By 7 a.m. on October 18, Lee was ready to order the attack. Lt. J. E. B. Stuart, who accompanied Lee to Harpers Ferry from Washington, was instructed by Lee to conduct a parley with Brown in the hopes of ending the standoff without further violence. When the parley failed, in a pre-arranged signal for the Marines to attack, Stuart waved his hat in the air. At that gesture, the Marines stormed the engine house, using a ladder as a battering ram. Upon entering the building, several moments of melee ensued, with several raiders (Dauphin Thompson and Jeremiah Anderson) and one Marine (Pvt. Luke Quinn) being killed almost immediately. Brown was wounded but survived the onslaught. From gaining entrance to the engine house to subduing the raiders and freeing the hostages, the entire operation took a total of three minutes.

Despite Brown's admonishment to his raiders on the eve of the raid on October 16 to not "take the life of anyone if you can possibly avoid it," the raid resulted in numerous deaths. Ironically, the first person killed by Brown's raid against slavery was Heywood Shepherd, a free black who worked for the B&O Railroad in town. This monument to Heywood Shepherd sits at the corner of Shenandoah and Potomac Streets.

The mayor of Harpers Ferry, Fontaine Beckham, was also killed by the raiders on the first day of the raid, October 17, 1859. Beckham, also an agent for the B&O Railroad, was a friend of fellow B&O Railroad worker Heywood Shepherd and was reportedly disturbed by his fatal wounding by the raiders. When Beckham, unarmed, went within 30 yards from the Armory to get a better view, he was shot by raiders. This summons was signed by Beckham as Justice of the Peace for Jefferson County in 1847.

THE COMMONWEALTH OF VIRGINIA,

To the Constable of Jefferson County, Greeting:

You are hereby commanded to summon ~~bil Howard~~
to appear before me or some other Justice of the Peace for the said county,
at ~~Thomas office~~ on the 1st Saturday in ~~August~~ 1847.
to answer ~~Peter Miller~~ in a plea of debt for
~~Two~~ Dollars and ~~Fifty 1/2~~ Cents, due by
~~a act~~ and then and there make return how you have executed this warrant. Given under my hand this 12th day of ~~July~~ 1847

F. Beckham

Jefferson County, to wit:

To the Constable of Jefferson County, Greeting:

You are hereby commanded that of the goods and chattles of
in your district, you cause to be made the sum
of Dollars and Cents, which
lately before
one of the Commonwealth's Justices of the Peace for the
County of Jefferson, hath recovered against him for debt, with six per cent. interest from the
day of 184 , till paid, and Cents cost,
and make return thereof on the day of 184
Given under my hand, this day of 184

Other prominent townspeople killed by the raiders include George Turner, a West Point graduate and farmer in town, and Thomas Boerly, a grocer and amateur pugilist. Ten of the 21 raiders also died during the raid. John Kagi, one of Brown's most trusted men, met his demise on a large rock in the middle of the Shenandoah River. Kagi was gunned down by townspeople as he attempted to swim across the Shenandoah River to safety.

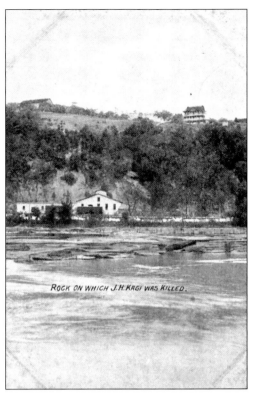

ROCK ON WHICH J.H.KAGI WAS KILLED.

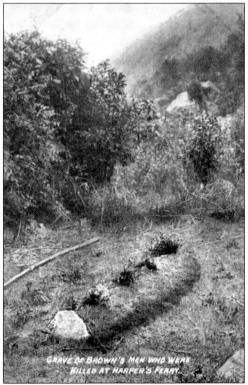

GRAVE OF BROWN'S MEN WHO WERE KILLED AT HARPER'S FERRY.

Nine of the 10 raiders who died during the raid were entombed in two large "store boxes" and buried in an unmarked communal grave on the banks of the Shenandoah River. The location of this grave was about a half-mile upriver from Harpers Ferry. In 1889, the original grave digger led relatives back to the site, and the bodies were exhumed, transported to North Elba, New York, and buried next to the grave of John Brown.

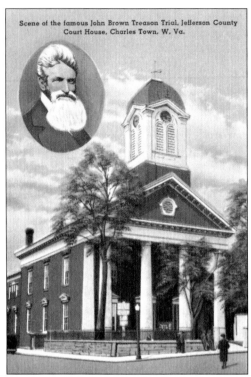

Scene of the famous John Brown Treason Trial, Jefferson County Court House, Charles Town, W. Va.

Only 5 of the 20 raiders were able to escape Harpers Ferry and flee north. The remaining six raiders who survived their capture were held by the State of Virginia and put on trial at the Jefferson County Courthouse in nearby Charles Town, roughly eight miles from Harpers Ferry. Andrew Hunter, one of the prosecutors, promised to have Brown "arraigned, tried, found guilty, sentenced and hung, all within ten days."

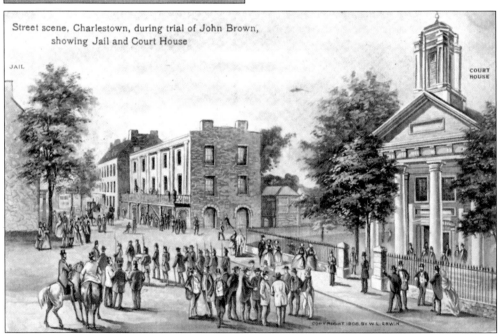

Street scene, Charlestown, during trial of John Brown, showing Jail and Court House

JAIL

COURT HOUSE

This 1908 Erwin postcard shows the courthouse in relation to the jail where John Brown was held from late October until December 2, 1859, when he was executed by the State of Virginia. The jail is located at the left, while the courthouse is depicted across the street at the right. Note that soldiers are escorting John Brown back to his jail in this card, with Brown in the middle of the troops.

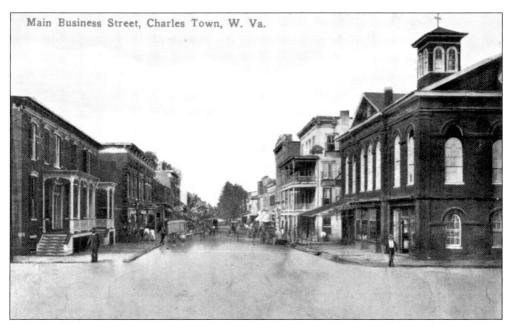

Main Business Street, Charles Town, W. Va.

This view is from the approximate spot in the middle of the road in front of the courthouse where John Brown was depicted with troops in the last postcard on the previous page. The building to the immediate left on this card was the old Charles Town jail. The jail was torn down in 1919 to make way for the post office.

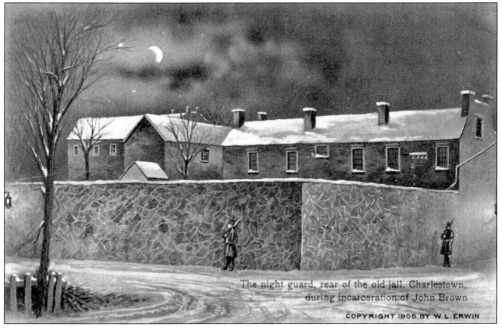

The night guard, rear of the old jail, Charlestown, during incarceration of John Brown

COPYRIGHT 1905 BY W. L. ERWIN

This card depicts the back of the jail. John Brown promised his jailer, John Avis, that he would not attempt escape. However, after Brown's execution, two other raiders did attempt escape but only made it as far as the back courtyard. Had they attempted their escape a day earlier, they might have succeeded, as a disguised Northern abolitionist was on guard outside the exterior of the wall the night before and was prepared to assist in the escape.

41

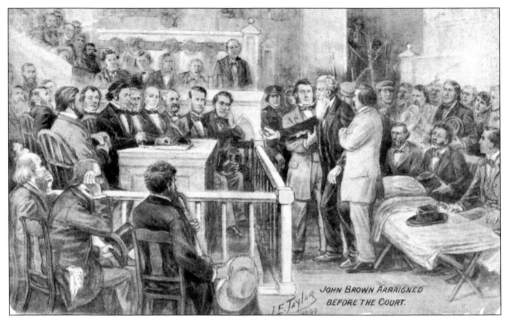

JOHN BROWN ARRAIGNED
BEFORE THE COURT.

John Brown was arraigned on October 25, 1859, just one week after the raid and, after indictment, was the first to be put on trial. He was charged with treason against Virginia, conspiring with slaves to rebel, and murder. After a three-and-a-half-day trial, the jury returned a guilty verdict on October 31 after approximately 45 minutes of deliberation. Two days later, on November 2, Judge Parker sentenced Brown to death by hanging.

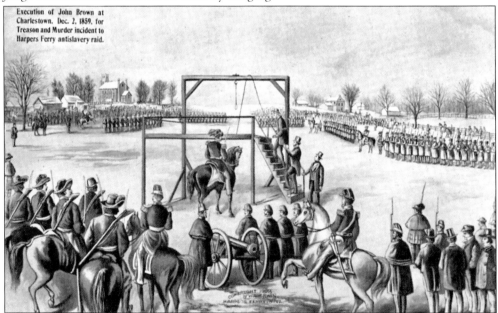

Execution of John Brown at Charlestown, Dec. 2, 1859, for Treason and Murder incident to Harpers Ferry antislavery raid.

In the late morning of December 2, 1859, John Brown was led out of the jail, made to sit atop his own coffin in the back of a wagon, and transported several blocks to the execution site. The gallows were guarded by 1,500 soldiers, among them cadets from the Virginia Military Institute led by their eccentric professor, Thomas "Stonewall" Jackson. Also present was John Wilkes Booth, who would commit his own act of treason by assassinating President Lincoln in 1865.

On December 2, by orders of Virginia governor Henry Wise, citizens of Jefferson County were "emphatically warned to remain at their homes armed and guard their own property." While no civilians were permitted at the execution site (located in a field on what was then known as the Rebecca Hunter farm), some residents viewed the execution from the rooftops and upper-story windows of several homes that overlooked the location.

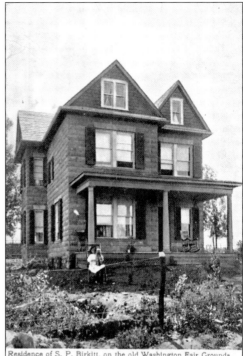

Residence of S. P. Birkitt, on the old Washington Fair Grounds, Charlestown, W. Va., overlooking scene of the execution of John Brown

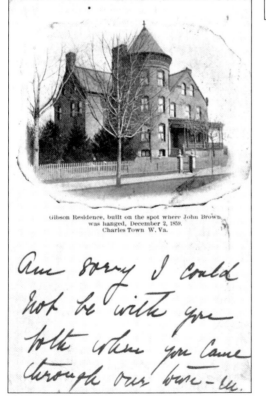

Gibson Residence, built on the spot where John Brown was hanged, December 2, 1859. Charles Town W. Va.

Am sorry I could not be with you folk when you came through our town — W.

Col. John Gibson commanded approximately 800 of the soldiers standing guard at the gallows. After the Civil War, Colonel Gibson bought the land and erected a brick Victorian residence in 1892, on the site where Brown was executed. The north wall of this home was erected at the gallows' location, and a marker near the north wall of the house bears John Brown's name and the date December 2, 1859. The residence is located at 515 South Samuel Street.

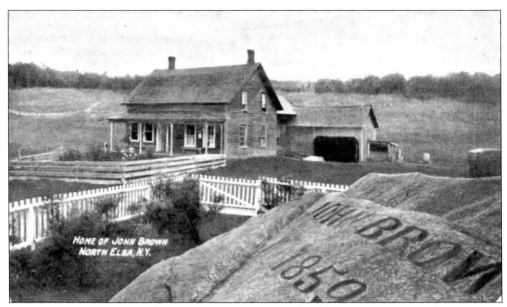

After the execution, Brown's body was sent north for burial at his farm at North Elba, New York, the experimental community where Brown had toiled alongside his black neighbors on land given to them by wealthy abolitionist Gerrit Smith. Brown's grave is beside the giant rock pictured here. In 1899, nine fellow raiders were exhumed from the unmarked grave at Harpers Ferry and reburied at the John Brown Farm.

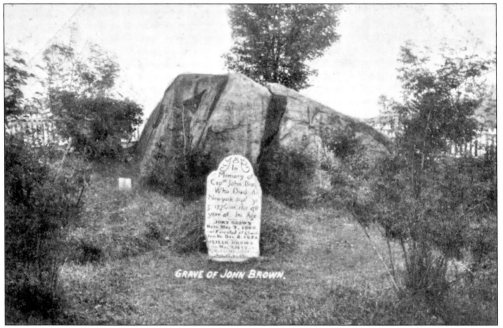

Shortly before his death, John Brown gave his jailer a short, two-sentence note in which he wrote: "I, John Brown, am now quite certain that the crimes of this guilty land will never be purged away but with blood. I had, as I now think vainly, flattered myself that without very much bloodshed it might be done." Even though John Brown's body was now "a mouldering in the grave," his legacy would go "marching on."

Four

HARPERS FERRY DURING THE CIVIL WAR

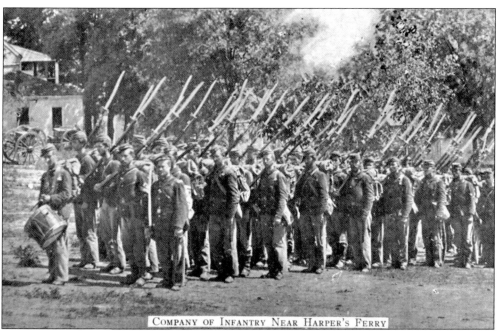

COMPANY OF INFANTRY NEAR HARPER'S FERRY

Within a year and a half of John Brown's prophetic words, the Civil War had commenced, with hundreds of thousands of Americans spilling blood upon sacred fields, and Harpers Ferry continued to play a major role. As Confederate general Stonewall Jackson commented to General Lee in 1861: "this place could be defended with the spirit which actuated the defenders of Thermopylae, and if left to myself, such is my determination. The fall of this place would, I fear, result in the loss of the northwestern part of the State, and who can estimate the moral power thus gained and lost to ourselves?" This postcard depicts Union troops at Harpers Ferry in 1862. The building in the background is the Odd Fellows building, still standing today.

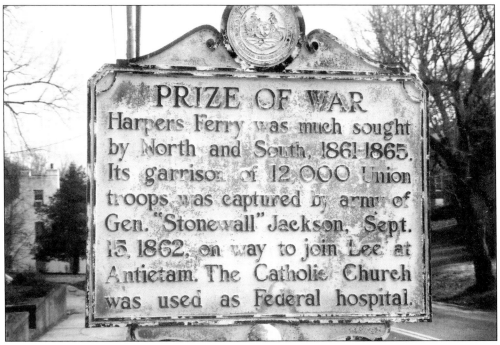

PRIZE OF WAR

Harpers Ferry was much sought by North and South, 1861-1865. Its garrison of 12,000 Union troops was captured by army of Gen. "Stonewall" Jackson, Sept. 15, 1862, on way to join Lee at Antietam. The Catholic Church was used as Federal hospital.

From 1861 to 1865, the town of Harpers Ferry would be occupied by both the Northern and Southern armies and was a sought-after "prize of war." However, by the end of the war, the town was desolate. A Union officer explained that "the appearance of ruin by war and fire was awful. Charred ruins were all the remain of the splendid public works, arsenals, workshops, railroads, stores, hotels, and dwelling houses all mingled in one common destruction."

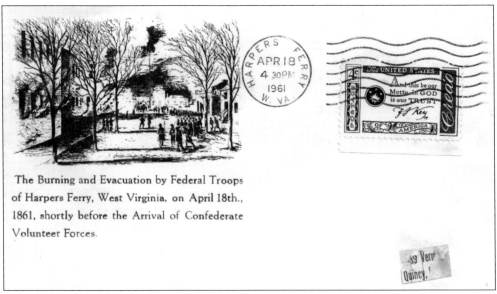

The Burning and Evacuation by Federal Troops of Harpers Ferry, West Virginia, on April 18th., 1861, shortly before the Arrival of Confederate Volunteer Forces.

After Virginia announced its secession from the Union in April 1861, Confederate forces marched on the town, and the town became the headquarters for Gen. Stonewall Jackson and his forces in May–July 1861. This envelope was produced to commemorate the centennial of the burning of the Armory in April 1861 and was mailed from Harpers Ferry on the 100th anniversary.

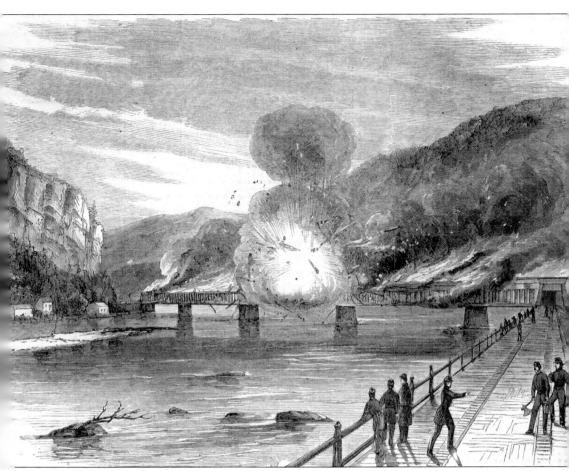

This wood carving, from *Harper's Weekly*, depicts the destruction of a railroad bridge—a bridge that would be repeatedly destroyed and rebuilt. When Lincoln visited Harpers Ferry in October 1862, he made a specific point of visiting this railroad bridge—so often destroyed during the war. Because the bridge was rebuilt and destroyed so many times, the Union army built a pontoon bridge across the Potomac River in late 1862 (see page 59). The pontoon bridge became indispensable for the Union forces in town from late 1862 through 1865.

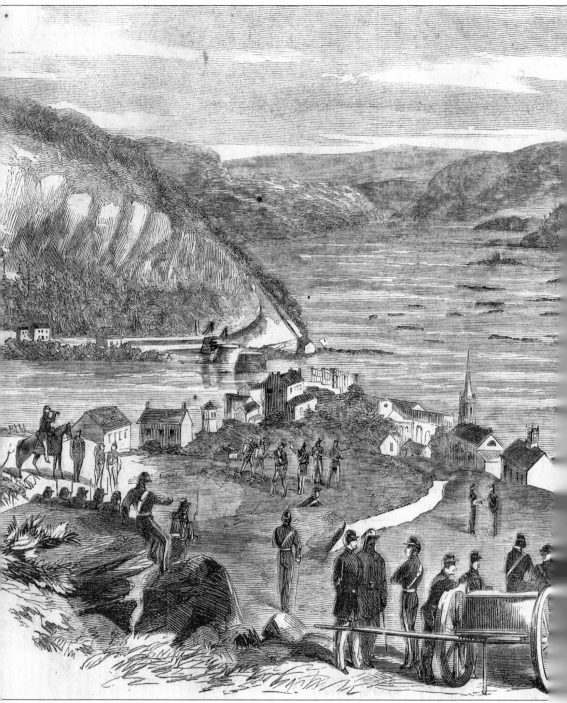

In July 1861, Confederate forces vacated the town. Many townspeople also vacated the town during this time period as well. By fall 1861, chaos reigned. According to eyewitness Joseph Barry, "not only were the government buildings ransacked for plunder, but the abandoned houses of the citizens shared the same fate. Even women and children could be encountered at all hours of the day and night loaded with booty or trundling wheelbarrows freighted with all

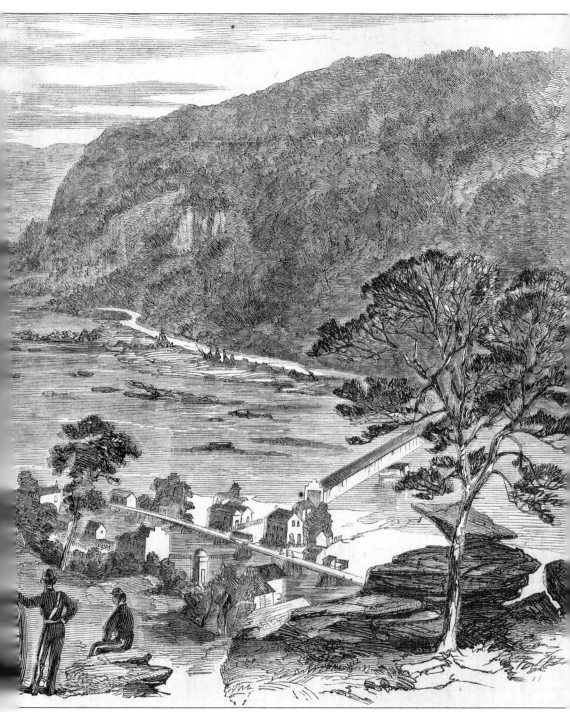

imaginable kinds of portable goods and household furniture." By the winter of 1861–1862, even the looters were gone. Again as described by Joseph Barry, "all that winter—61–62, Harpers Ferry presented a scene of the utmost desolation. All the inhabitants had fled, except a few old people, who ventured to remain and protect their homes, or who were unable or unwilling to leave the place and seek new associations."

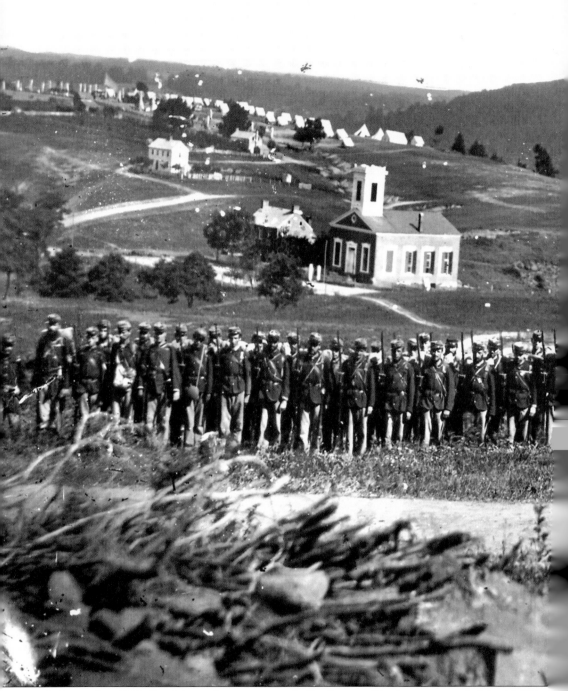

In September 1862, Confederate forces commanded by Stonewall Jackson surrounded the 12,693 soldiers in the Union garrison at Harpers Ferry and lay siege to the town. After approximately three days, the Union troops surrendered, and Jackson marched to meet Gen. Robert E. Lee at Antietam. This photograph of Union troops (22nd New York, Company A) is believed to have been taken in 1862. The Lutheran church in the background was used as a hospital during the

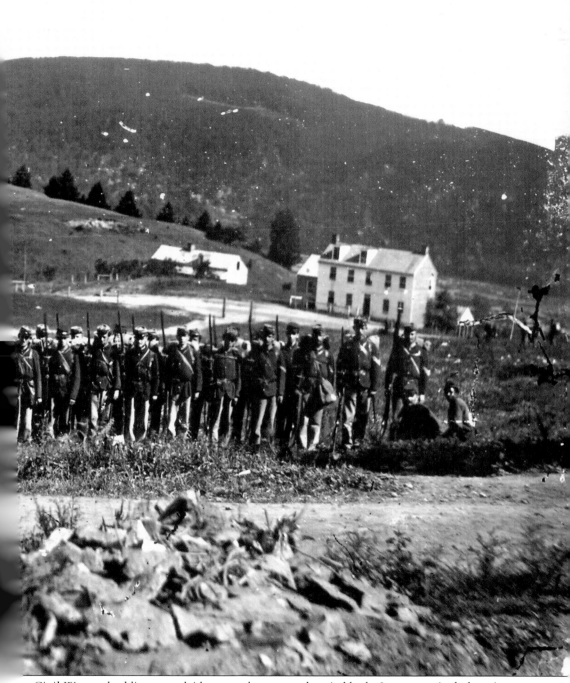

Civil War, and soldiers were laid out on the pews as hospital beds. In one particularly poignant postwar account, a nurse described the scene of carnage in this church after the battle of Antietam—with a sea of amputated limbs thrown out the windows and onto piles of discarded body parts. (Image Courtesy of the National Archives.)

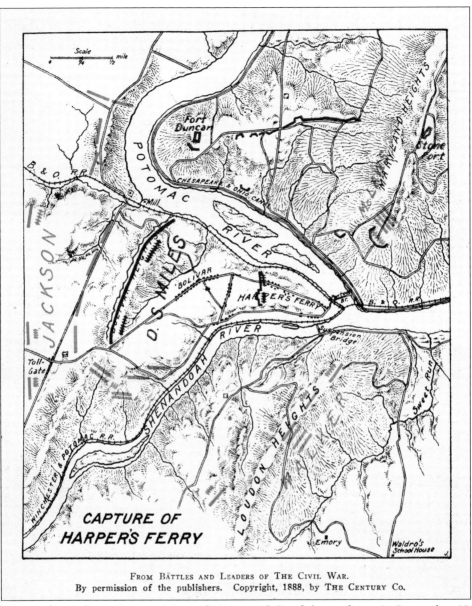

This map shows the various positions of Union and Confederate forces in September 1862 during the siege of Harpers Ferry. On the first day of the siege, approximately 2,000 Union troops gave up the very valuable high ground of Maryland Heights, allowing Gen. Lafayette McLaws to position cannon on the strategic heights to bombard the town and Union garrison below. Gen. Reuben Lindsay Walker took Loudoun Heights as well, which was unoccupied and undefended by Union forces. When Gen. Stonewall Jackson approached Bolivar Heights by way of Schoolhouse Ridge, the Union garrison of 12,693 was trapped and surrounded by Confederate forces on three sides. Note the main Union forces were deployed on Bolivar Heights, with several thousand soldiers in the Camp Hill area. After three days of cannonade and destruction, and when forces under Gen. A. P. Hill began to flank the Union position of Dixon Miles along the banks of the Shenandoah, the Union forces surrendered. The Union surrender represented the largest wholesale surround of Union forces in the Civil War.

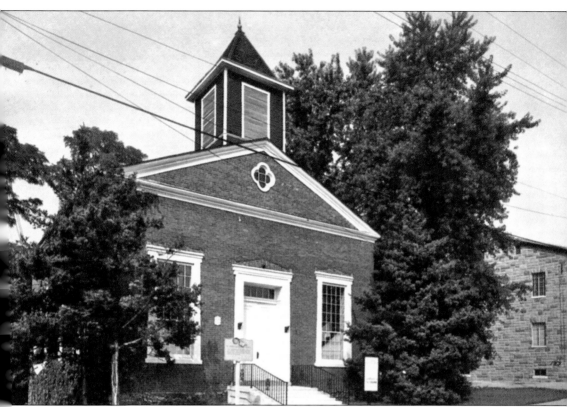

St. John Lutheran Church, on Washington Street near its intersection with Union Street, was erected in 1850. On the day the cornerstone was laid, in April 1850, one local resident wrote that "the wind blew so hard that we expected the fences all to be blown down." The church is largely a one-story building, with a balcony that was used early on by black parishioners. The window and door frames are said to be of the Egyptian Revival style. Citizens of the town first learned of John Brown's raid when a local doctor, hearing shots and seeing the raiders, rode his horse to the church and rang the bell to alert the town of the impending danger. Today the bell is still rung once or twice before service on Sundays. The church played a prominent role as a hospital during the war. This is the same church behind the fine-looking company of Union troops depicted on pages 50–51.

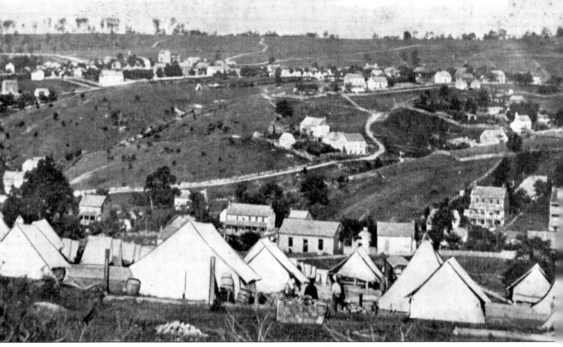

Soldiers pitched their tents on the west side of Camp Hill, as it sloped down to Union Street. The houses immediately below the tents were situated on Union Street—the dividing line between Harpers Ferry and Bolivar. Note the three soldiers standing in the middle of the tents. At the ridge is Bolivar Heights, the site of the surrender of 12,693 Union soldiers to Confederate forces in September 1862. Afterwards, it became the location of a large encampment for Union forces. As one war correspondent wrote, "Our army moved done the left bank of the Potomac, climbing the narrow torturous road that winds around the foot of the mountains; under Maryland Heights; across the long, crooked ford above the blackened timbers of the railroad bridge; then up among the long, bare deserted walls of the ruined Government Armory, past the deserted engine-house which Old John Brown made historic; up the dingy, antique oriental looking town of Harper's Ferry, sadly worn, almost washed away by the ebb and flow of war; up through the village of Bolivar to these Heights, where we pitched our tents."

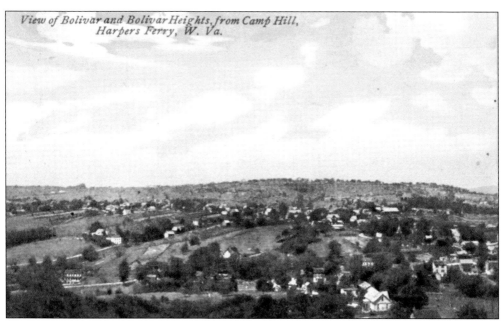

View of Bolivar and Bolivar Heights, from Camp Hill, Harpers Ferry, W. Va.

This postcard view, probably taken from the cupola of Anthony Memorial Hall on the Storer College campus, shows Union Street (immediate street in the foreground), the village of Bolivar, and Bolivar Heights in the distance. Note the house along the bottom right border of this postcard. This house—the Chapman-Weaver House located at 328 Union Street—marks the top of Union Street and is adjacent to the Washington Street–Union Street intersection. The back of the card is dated June 14, 1913, and reads, in part, "we are only nine miles from this large city and fine Auto road."

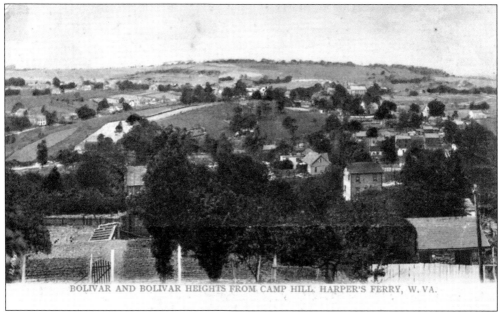

BOLIVAR AND BOLIVAR HEIGHTS FROM CAMP HILL. HARPER'S FERRY, W. VA.

In a 1910 postcard, Bolivar is depicted from Camp Hill. At the middle right-hand side of the card, the first few houses on Union Street are visible (the first house partially obscured by trees), all built from 1847 to 1850.

55

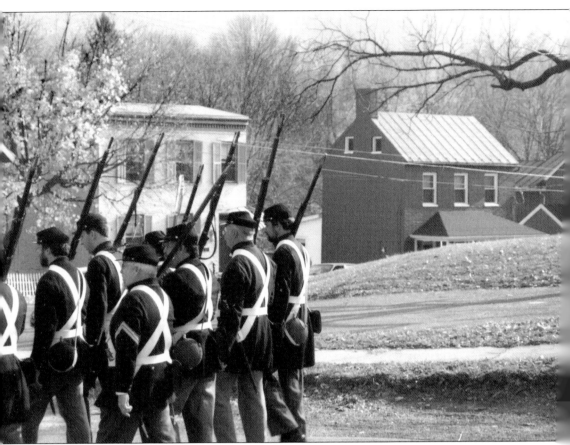

Taken from Bolivar looking towards Union Street (and Camp Hill in the tree line behind the houses), this photograph captures the reverse angle from the previous three postcards. The first house on Union Street, the Chapman-Weaver House, is shown above the heads of the reenactment soldiers. The history of this house, erected in 1847, is representative of the fascinating history that most houses have in the towns of Harpers Ferry and Bolivar. Prior to the Civil War, an armory worker (John Chapman) resided in the house with his family, but they left when the armies moved into town—and occupied the houses. In 1867, the house was acquired by a freed slave, George Weaver, with the financial assistance of Storer College; he would reside in the house for the next half century with his family. George Weaver, a respected black business leader who ran an ice harvesting business, was also a registered voter by 1892, over a half century before the Voting Rights Act of 1965. Several of his children also attended classes at Storer College.

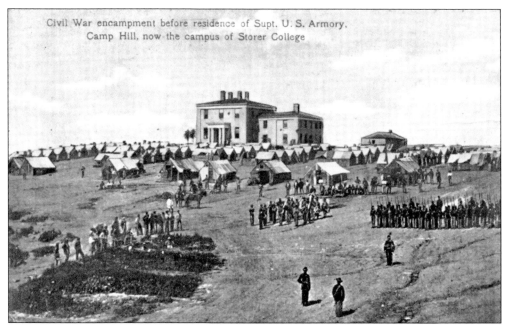

On the east side of Camp Hill, the Union army encamped and made its headquarters. The main building is today part of Anthony Hall. According to eyewitness Joseph Barry, the town was "dotted with tents, and at night the two villages and the neighboring hills were aglow with hundreds of watchfires. From Camp Hill the ridge that separates the towns of Harpers Ferry and Bolivar the spectacle was magnificent, especially at night."

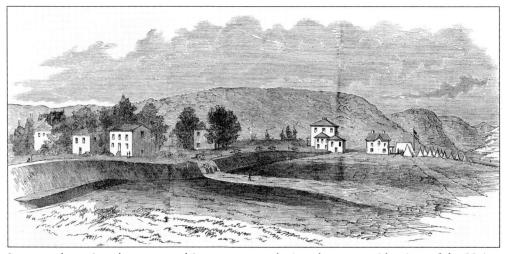

In a wood carving that appeared in newspapers during the war, a side view of the Union encampments is depicted. The three buildings to the right on this drawing are the same three buildings depicted in the previous postcard.

Abraham Lincoln visited Harpers Ferry for two days on October 2–3, 1862, after the battle at Antietam. According to the front page of *The New York Times* (Friday, October 3, 1862), Lincoln arrived at Harpers Ferry on a special train provided by the Baltimore and Ohio. Upon arrival, and after meeting with several general officers—including Gen. George McClellan—Lincoln and McClellan roamed through the town. Lincoln visited John Brown's Fort and was heard to make a joke at the expense of the Virginians at Harpers Ferry and how they handled Brown's raid: "It reminds me of the Illinois custom of naming locomotives after fleet animals, such as the Reindeer, the Antelope, the Flying Dutchman and so forth. . . . At the time of the John Brown raid, a new locomotive was named . . . 'the Scared Virginians.' " Lincoln also reviewed troops on Bolivar Heights, Maryland Heights, and Loudoun Heights. After spending the night in Bolivar and visiting more troops in the morning, Lincoln then departed to tour the Antietam battlefield.

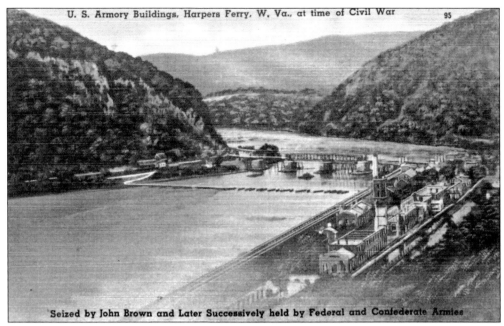

Seized by John Brown and Later Successively held by Federal and Confederate Armies

This postcard depicts the abandoned Armory buildings during the Civil War, as well as the pontoon bridge built by the Union army in order to cross troops and supplies across the Potomac River. The railroad bridges were destroyed multiple times, thereby dictating the need for the pontoon bridge.

Even though the town lost virtually all of its military and strategic importance after the Civil War, the town still occasionally served as the site of National Guard training. This postcard commemorates the National Guard of Washington, D.C., which encamped several times at Harpers Ferry in the early 20th century. Today the semblance of any military presence in town comes from either reenactment units or actual military members making an educational "staff ride" visit to town. Indeed, this author, an ex–active duty army member himself, once hosted his unit (U.S. Army Claims Service) for a visit to town.

Just a line from your Soldier Boy
 To tell you how I miss you,
And how much more cheery
I'd feel, my dearie,
 Were you here where I could kiss you!

A Throb
From

Harpers
Ferry

But since I am denied that joy
 By Fate, so blamed contrary!
Pray, think of the old N. G. D. C.,
And most particularly of ME,
 Encamped at Harpers Ferry.

59

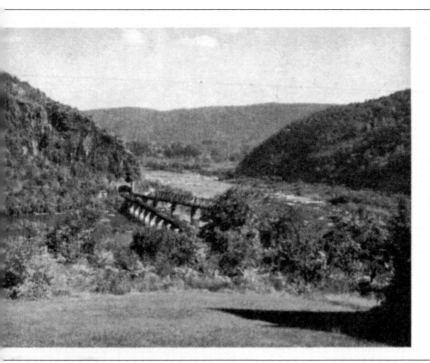

CONTINUAL CONFLICT AT HARPERS FERRY

★ ★ ★ ★

BATTLE OF BOLIVAR HEIGHTS

October 16, 1861

At the centennial of both John Brown's raid (1859) and the Civil War (1861–1865), a variety of postcards was produced to commemorate the events. This postcard commemorates one of the first major battles in town, a battle for control of Bolivar Heights. The battle took place on October 16, 1861, when federal forces under Col. John Geary removed Confederate forces under Col. Turner Ashby from their positions on Bolivar Heights. Several days later, on October 20, 1861, the front page of the *New York Herald* declared the fighting and maneuvering of Geary and the approximate thousands troops under him to be "brilliant."

Five

THE STORY OF
JOHN BROWN'S FORT

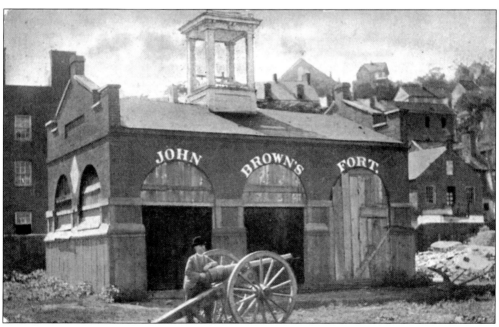

John Brown's Fort should rightfully be considered to be one of America's most famous structures. From its construction in 1848, it has been vandalized and subject to the carvings of generations of souvenir hunters, dismantled and moved to Chicago, and reacquired by Harpers Ferry and eventually rebuilt. This chapter tells the unique story of this building through the various postcards over time.

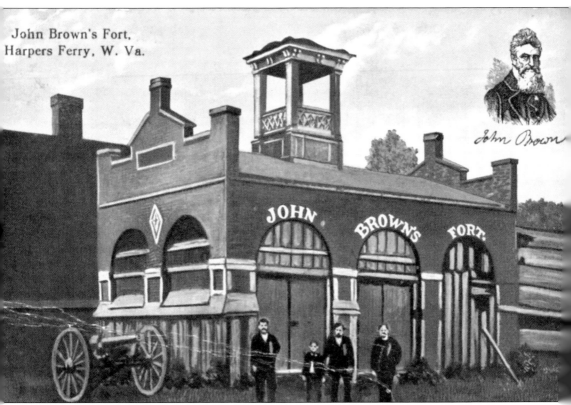

John Brown's Fort,
Harpers Ferry, W. Va.

While designed as a fire engine house, the building's claim to fame was in serving as John Brown's stronghold, or fort, during Brown's famous raid on Harpers Ferry in October 1859. After a one-day standoff, then–Lt. Col. Robert E. Lee ordered a contingent of U.S. Marines to capture Brown. After a brief but desperate fight, Brown was compelled to surrender. The building became subsequently known as John Brown's Fort and for years was an object of interest to passengers on the B&O Railroad, as trains would pass immediately by the building. The building was vandalized greatly both during and after the Civil War. For example, the bell that once hung from the cupola of the building was removed by Union soldiers from Massachusetts, and today the bell is on display in Marlboro, Massachusetts. Commenting on its dilapidation in 1862, Nathaniel Hawthorne stated that "it is an old engine house, rusty and shabby, like every other work of man's hands in this God-forsaken town."

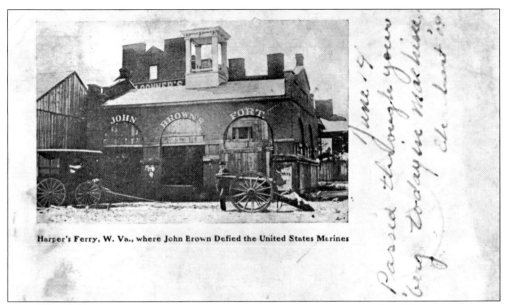

Harper's Ferry, W. Va., where John Brown Defied the United States Marines

According to a June 30, 1848, Armory report, the building was described as follows: "An engine and guard house, 35 1/2 x 24 feet, one story brick, covered with slate, and having copper gutters, and down spouts, has been constructed and is now occupied." Note the man and woman posing by the cannon in this postcard. The woman is lying across the frame of the cannon.

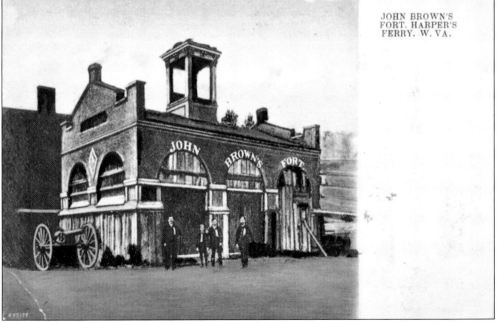

JOHN BROWN'S FORT. HARPER'S FERRY. W. VA.

In 1891, the fort was dismantled and shipped to Chicago, where it was an exhibit at the Chicago Exposition (the exhibit closed after 10 days when it only attracted 11 people—paying 50¢ a day to see it). Thus the early-20th-century postcards of the fort (like this postcard dated 1907) are based upon images created prior to 1891. This picture (used by multiple postcards) was believed to have been taken around 1890.

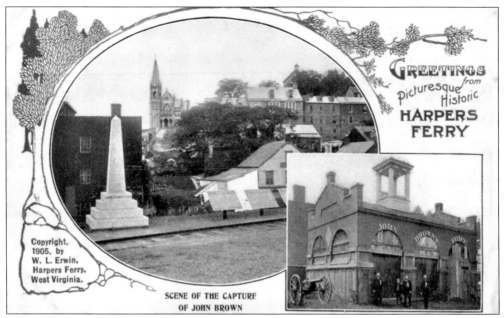

SCENE OF THE CAPTURE OF JOHN BROWN

This 1905 Erwin postcard shows the original fort and where it would have been located in the town, marked by the white obelisk in the circular image of this card. The building directly behind the obelisk was the location of the locally well-known Dittmeyer's Pharmacy in the early 20th century. Walter Dittmeyer, along with W. L. Erwin, produced many of the earliest postcards of the town.

Most of the postcards of John Brown's Fort in the late 19th and early 20th century depict a 10-pound Parrot rifle cannon adjacent to the fort. When the fort was dismantled, the cannon remained. In 1924, the cannon was moved up to the town's park in Camp Hill and was mounted in concrete and displayed there, where it is still visible today. The concrete base of the cannon lists two dates, 1865 and 1924.

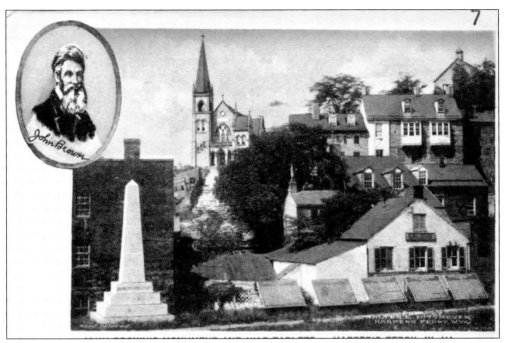

The base of the monument depicted here would be about where the fort's cupola would have been located. The obelisk, still standing today, overlooks Shenandoah Street as well as many of the buildings in lower town. The Civil War tablets depicted here have been moved to another location in lower town.

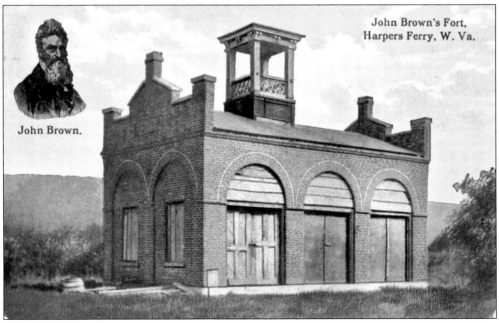

John Brown's Fort, Harpers Ferry, W. Va.

John Brown.

After John Brown's Fort was dismantled and moved to Chicago for display in 1891, a local woman, Mary Kate Fields, rescued the fort from the slated destruction that was pending for the structure and had it moved back to a farm several miles away from Harpers Ferry in 1895. For the next 14 years, the fort resided several miles from Harper Ferry.

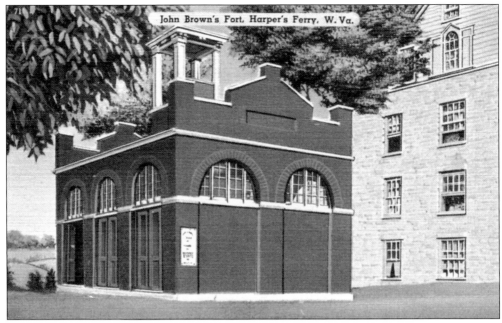

On the 50th anniversary of John Brown's Raid in 1909, the fort was again dismantled and moved back to Harpers Ferry, to reside on the Storer College campus adjacent to Lincoln Hall (today the picnic area adjacent to the Interpretive Design Center). For roughly the next 60 years, from 1909 to 1968, the building would remain at Storer College at this location, used as a library and museum for the college.

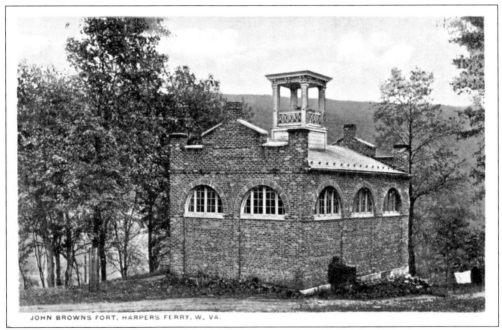

The building, seen here on the Storer College campus around 1915, would remain at Storer College in Harpers Ferry until 1968, when the National Park Service moved the building back down to lower town, where it now is situated within about 150 feet of its original location.

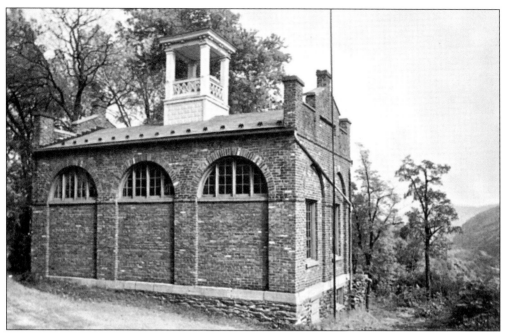

John Brown's Fort is depicted here in the 1950s. The caption on the back of the card reads that the fort is "now located on the campus of Storer College, Harpers Ferry." Storer College permanently closed its doors in 1955.

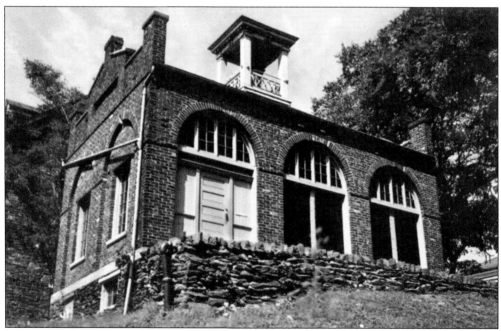

This undated postcard shows a different view of the fort, and the back of the card reads that "this structure, still preserved on the campus of Storer College at Harpers Ferry, served John Brown as his fort when the Kansan staged his daring raid to free the slaves in 1859."

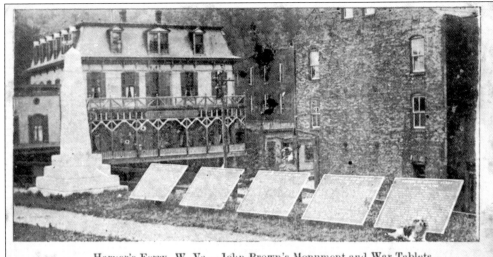

Harper's Ferry, W. Va.—John Brown's Monument and War Tablets.

The obelisk marks the original location of John Brown's Fort. To the immediate right of the obelisk (and across Shenandoah Street) is the Hotel Conner, a popular hotel in the late 19th and early 20th centuries. The fort was moved to the location of this old hotel in 1968 (the hotel was demolished after the flood of 1936), which is where John Brown's Fort has rested since 1968. Note the dog lying beside the last historical marker on the bottom right of the postcard.

This postcard depicts the fort soon after its relocation in 1968, when it was moved by the National Park Service a short distance away from its original location. It is currently situated on Shenandoah Street at the approximate location of the old Hotel Conner.

Six

EARLY STREET VIEWS AND BUILDINGS

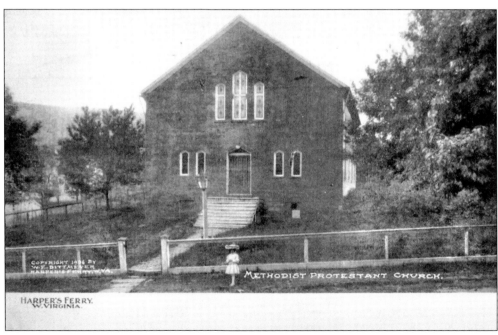

This postcard depicts the Camp Hill–Wesley United Methodist Church on Washington Street, adjacent to the Gilmore Street and Washington Street intersection. The original Methodist church was located in lower town but was destroyed during the Civil War. This church was built at this location in 1869 with bricks from the old Armory complex. A steeple was built in 1947 and the windows modified. Note the little girl in her Sunday best in this 1906 postcard.

At the Herr's Island bridge, along the Shenandoah

Depicted here is Shenandoah Street, a major road leading to lower town back when the street was still a dirt path. The bridge led to Virginius Island, initially named after Abraham Herr, as he owned a large flour mill on the island during the Civil War. This bridge washed away in a flood but was later reconstructed in 1974. Note the man standing next to the tree. The sender wrote, "this is a bridge we walked over many times."

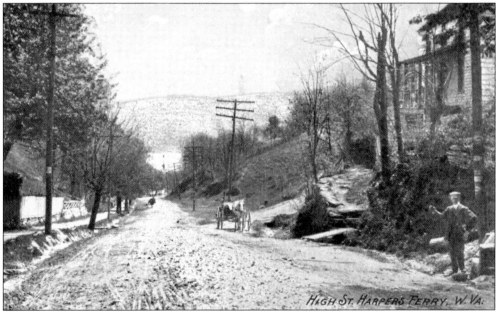

HIGH ST. HARPERS FERRY, W. VA.

Depicted here is Washington Street (also called High Street)—another road leading down to lower town and connecting it with Camp Hill and the adjacent village of Bolivar. The man is standing by one of the old town springs and holding up a glass of water. His horse and buggy is "parked" at the intersection of Clay and Washington Streets. Notice another horse and buggy in the distance—and above it, one of Harpers Ferry's first streetlights.

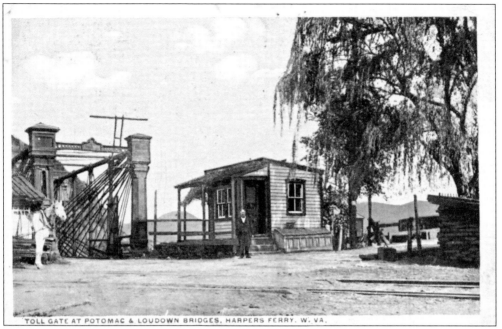

One could also travel to town in the late 19th and early 20th centuries from Virginia by way of the Shenandoah Bridge (entrance depicted at right of card) or from Maryland by going over the Bollman Bridge (entrance to bridge depicted at left). Pictured here is the tollbooth for those traveling across either bridge.

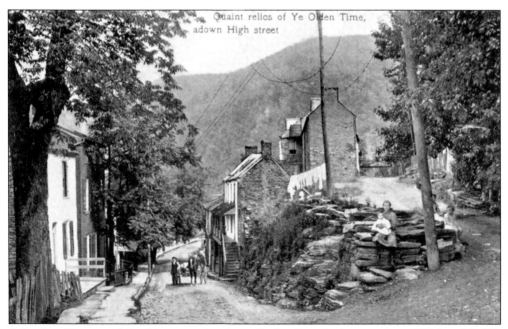

A family of four posed for this postcard at the wall of rocks at the intersection of High and Public Way Streets. The two children (to the right of the woman holding a child) appear to be shirtless, while laundry hangs on a line behind them. The caption on the postcard reads "Quaint relics of Ye Olden Time, adown High Street"—presumably referring to the houses and not the people!

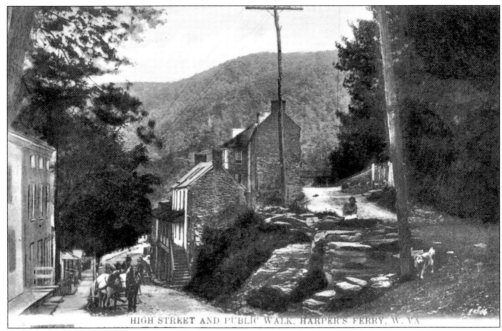

A woman and her dog are posing here, while a horse and buggy is climbing the steep incline of High Street. Dogs are pictured in several early postcards of the town, and despite the occasional hostile park ranger today with a vendetta against dogs on public lands, Harpers Ferry is still considered a dog-friendly town among most of the town occupants.

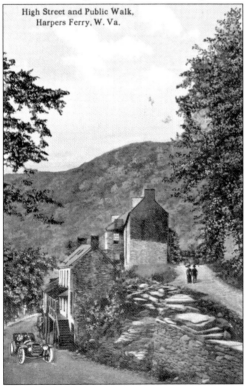

As the tourism trade picked up, so too did automobile traffic in town. As illustrated by this *c.* 1920 postcard, quaint horses and buggies were replaced with noisy automobiles. The row of buildings immediately to the left of the automobile was destroyed by fire in the early 20th century.

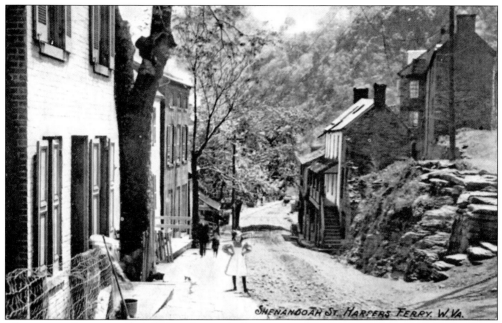

This postcard, incorrectly labeled Shenandoah Street, depicts a closer view of the intersection of High Street and Public Way. A girl is standing akimbo on the curb, with a mop and bucket leaning against the fence. Behind the girl, a man and a little girl are holding hands and walking up High Street. The homes at the far upper-right of this card are the Marmion Tenement House, the Wager House, and the Harper House—the oldest structure in town.

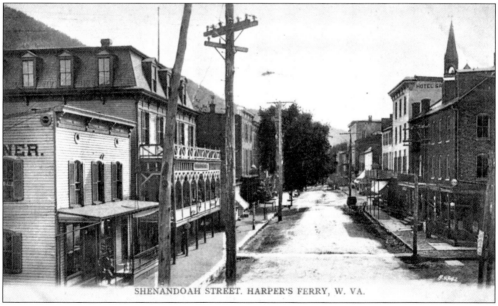

The intersection of Shenandoah and Potomac Streets is depicted at the bottom right of this card. Note the absence of hitching posts. According to the town ordinances of 1870, "no hitching post or posts shall be erected . . . [and] all hitching posts, save those erected by corporate authority are declared to be a nuisance." Further, "no person shall hitch his horse or horses, or other cattle to any post, or fence, or tree within the corporate limits."

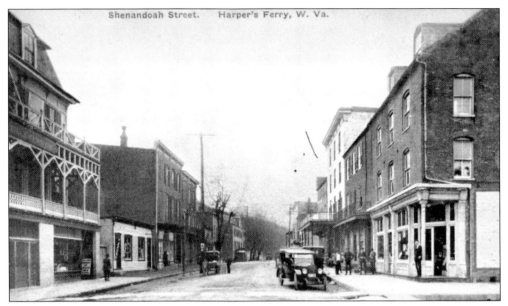

This postcard image, taken several years after the image on the previous postcard, shows that the horse and buggy (left-hand side of the street) is giving way to automobiles (right-hand side of the street). The card also poignantly illustrates the impact of the Great Depression on Harpers Ferry. The sender of the card wrote that he "stopped at store on the right. Men sat on kegs in this street as there was nothing else to do. Summer 1929."

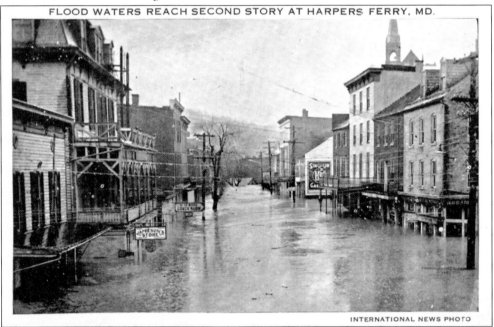

FLOOD WATERS REACH SECOND STORY AT HARPERS FERRY, MD.

INTERNATIONAL NEWS PHOTO

In addition to the economic hardships brought about by the Civil War and then the Great Depression, the town was also constantly under siege by the forces of nature, experiencing six major floods in the 20th century. This postcard depicts the floodwaters of the 1936 flood, which left many of the buildings in utter ruin and which still retains the record for the highest recorded floodwaters, cresting at 36.5 feet above normal levels.

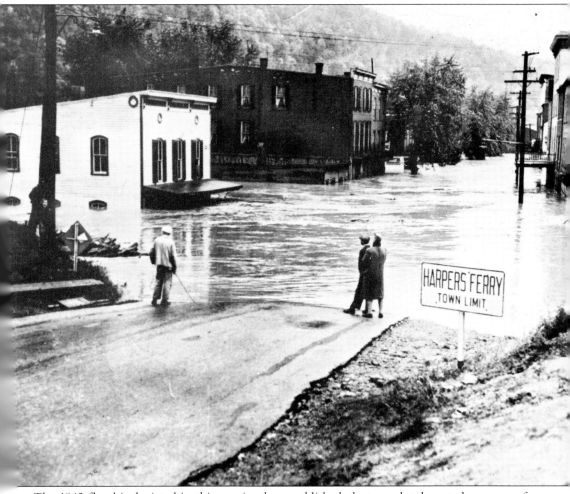

The 1942 flood is depicted in this previously unpublished photograph taken at the corner of Shenandoah and Potomac Streets. Note the gap between the first building on the left (at the time, the Harpers Ferry Post Office) and the next building, the practically submerged Blue Ridge Lunch Room. The Hotel Conner once occupied this space. All told, recorded floods have deluged the town in 1753, 1852, 1870, 1877, 1889, 1924, 1936, 1942, 1972, 1985, and 1996. While the flood of 1936 crested at the highest point, the flood of 1870 was by far the deadliest—destroying approximately 70 buildings in town, washing away several bridges, and taking the lives of 42 residents. As one witness described, "the sights and sounds we saw and heard there we shall never forget. . . . Every few minutes a low rumble would be heard, the startling signal that one of their once happy homes had sunk beneath the waters together with all their earthly possessions, or perhaps containing loved kindred and friends, whose dying wails could be heard on the midnight air."

This postcard image was likely taken from the Shenandoah Bridge and shows the buildings of Harpers Ferry along the banks of the Shenandoah River. The building with the arches was the town market (erected in 1846) from 1847 to 1868, where townspeople would buy and sell produce, meats, and other commodities. The building was destroyed by the flood of 1936. Note the three cows in the water at the left margin of the postcard.

Harper's Ferry, W. Va. - From Loudoun Heights.

The town market is again visible in this 1890s postcard. The proximity of residences to the rivers did have its advantages. However, according to the "Ordinances and By-Laws of Harpers Ferry," published in 1874, it was a crime to "bathe in the Potomac or Shenandoah rivers within the corporate limits, from sunrise until one hour after sunset." Violators of this law incurred a fine of not less than $1 or more than $3. The law did not prohibiting bathing altogether, just during daylight hours to protect the delicate sensibilities of some of the more proper residents.

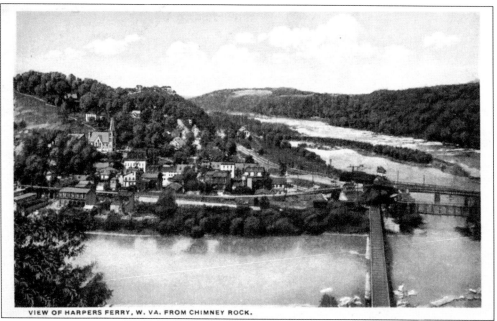

VIEW OF HARPERS FERRY, W. VA. FROM CHIMNEY ROCK.

This 1905 Erwin postcard shows the old Armory grounds on the banks of the Potomac from the railroad bridge. At the far end of the vacant Armory lot, the Harpers Ferry Power Plant is visible, which provided electricity to the town from 1925 to 1991, when the power plant shut down. The plant was erected upon the foundations of an 1854 armory building (Armory Rolling Mill), and the foundations are still visible today.

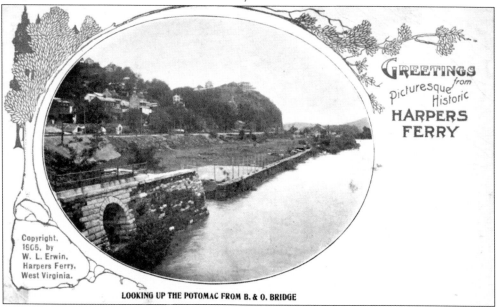

GREETINGS from picturesque Historic HARPERS FERRY

Copyright, 1905, by W. L. Erwin, Harpers Ferry, West Virginia.

LOOKING UP THE POTOMAC FROM B. & O. BRIDGE

While perhaps not as sweeping a view of Harpers Ferry as one could take in on the heights of neighboring Maryland Heights, the view from Chimney Rock offered early tourists a picturesque view of the town facing the Shenandoah River. Notice the wooden bridge in the foreground. This makeshift bridge was built on the remnants of the Shenandoah Bridge, which was destroyed by the flood of 1889.

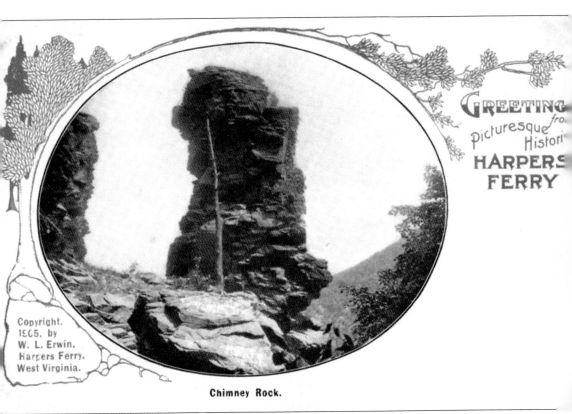

GREETING fro. picturesque Histori HARPERS FERRY

Chimney Rock.

Situated on the cliffs on Loudoun Heights above the Shenandoah River and opposite the town of Harpers Ferry, Chimney Rock is a natural geological formation that attracted early tourists who visited Harpers Ferry. Chimney Rock, as with the summit on Maryland Heights, served as a popular picnic site for the early tourists and gave earlier visitors a nice panoramic view of the town. W. L. Erwin's 1905 postcard of Chimney Rock was one of the earliest postcard images of this natural rock formation—which Prof. Millard K. Bushong referred to a "silent sentinel" guarding the town of Harpers Ferry from across the river. While a popular tourist site for over half a century, today it is largely inaccessible, and the National Park Service (which owns the land) has not opened up footpaths for visitors to visit this historically significant site. During the winter months, it is readily visible by visitors standing on or near the banks of the Shenandoah River on the Harpers Ferry side.

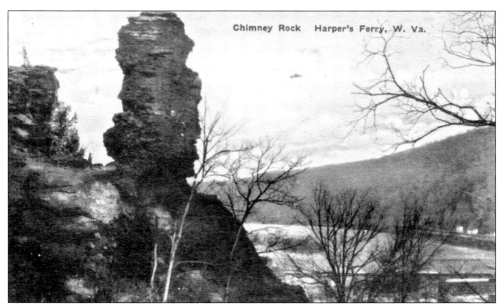

Chimney Rock is depicted with the Shenandoah River in the background. The image utilized for this card was taken in the 1880s, as the Shenandoah Bridge can be seen in the bottom right-hand corner of the card. Several buildings on the opposite shore of the Shenandoah River are visible. The sender of this card wrote on the back that they came here "to see the sights . . . and [we] are seeing them too—just been to John Brown's Fort."

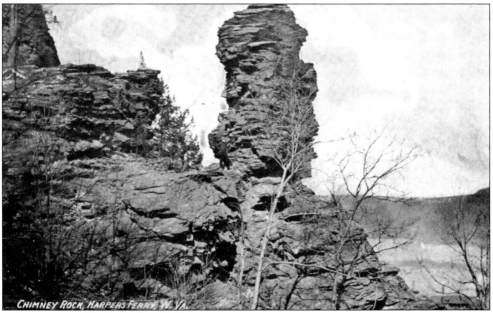

Dated August 1909, the sender repeats the oft-quoted verbiage of postcards over the ages, namely "wish you were here [and] am having a fine time." In seeing Chimney Rock, one can understand what the old poet and historian of Harpers Ferry, Joseph Barry, meant when he stated that Loudoun Heights seemed "sculptured by the hand of Nature" and that the "giant, dwarf, centaur and almost every other animal of Nature or of Fable" can be seen in the geological formations.

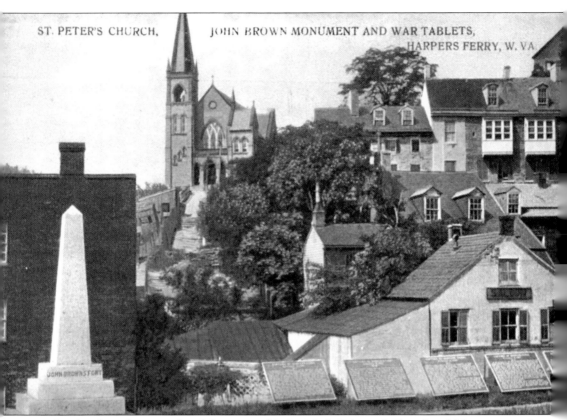

ST. PETER'S CHURCH, JOHN BROWN MONUMENT AND WAR TABLETS, HARPERS FERRY, W. VA.

The church at the top right of the postcard is St. John's Episcopal Church, which was erected in 1852. During the Civil War, it housed soldiers, including Confederate artillery soldiers at one point. Nathaniel Hawthorne visited this church in 1862 and described it as follows: "About midway of the ascent stood a shabby brick church, towards which a difficult path went scrambling up the precipice, indicating, one would say, a very fervent aspiration on the part of the worshippers, unless there was some easier mode of access in another direction." Also note the saloon at the bottom right of the card. Saloons outnumbered churches in town during this era. However, religious-minded individuals had at least one day of solace each week, as an 1870 town ordinance mandated that "all bar rooms, restaurants, saloons, except drug stores, and all other places of business shall be closed and kept closed during the entire Sabbath day." Further, "nor shall any person on the Sabbath day get drunk, quarrel, fight, pitch quoits, roll hoops, throw stones or missile, play bandy or ball, or marbles, fly kite, wrestle, jump, run foot races, sport, game, or be noisy or turbulent, or disorderly in any way whatever."

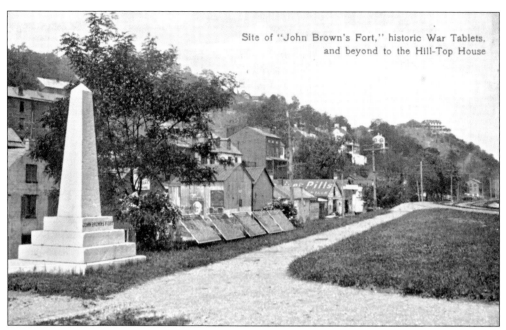

Site of "John Brown's Fort," historic War Tablets, and beyond to the Hill-Top House

This postcard depicts the buildings that lined Potomac Street in the early 20th century. Notice the advertisements on the sides of the buildings and on some of the roofs. One rooftop advertises "Pills"—proving that medicine was aggressively advertised in the 19th century as well.

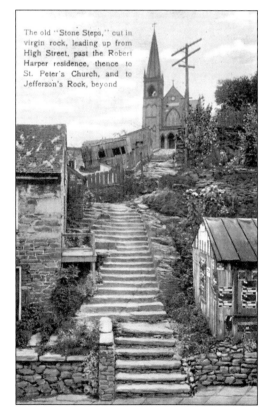

The old "Stone Steps," cut in virgin rock, leading up from High Street, past the Robert Harper residence, thence to St. Peter's Church, and to Jefferson's Rock, beyond

These "old 'Stone Steps,' cut in virgin rock," have been a popular tourist site and thoroughfare for townspeople since the early 19th century. These stairs lead from High Street to the oldest home (the Robert Harper residence), to St. Peter's and St. John's Churches, and to Jefferson's Rock. An electric light illuminated the upper steps at night. Many of the advertising posters on the building at the base of the Stone Steps (to the right) promote Bull Durham Tobacco.

81

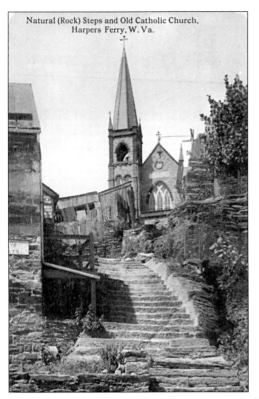

Natural (Rock) Steps and Old Catholic Church, Harpers Ferry, W. Va.

The 44 steps were carved out of a solid rock cliff when villagers first began to settle in the town. It has been estimated the stairs were carved into the rock by around 1810. A handrail was added in the early 20th century. The posters on the side of the building to the left (at second-floor level) advertise the product Magic Yeast.

The absence of a handrail on the stairs helps date this image as an earlier image involving the landmark. During military occupations of the town, St. Peter's Church was utilized as a makeshift hospital, and soldiers were detailed to carry wounded and dying soldiers up to the church. As such, the natural stone steps were said to "run red with blood" on many days during the war, and the stairs were called the "Bloody Stairs" by locals for many years.

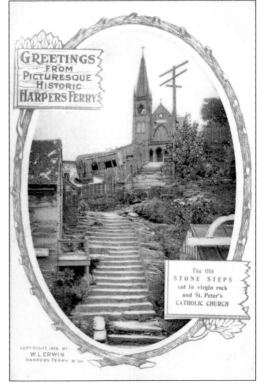

GREETINGS FROM PICTURESQUE HISTORIC HARPERS FERRY

The Old STONE STEPS cut in virgin rock and St. Peter's CATHOLIC CHURCH

COPYRIGHT 1906 BY W. L. ERWIN HARPERS FERRY W. VA.

According to local legend, during the Civil War, the priest in charge of the church, Rev. Michael Costello, allegedly would fly a British flag above the church and warned both Union and Confederate officers that any attempt to shell the church would be an act of aggression against Great Britain. This reputedly saved the church from destruction during the war. Reverend Costello is interred at St. Peter's Cemetery at the base of Union Street in Bolivar.

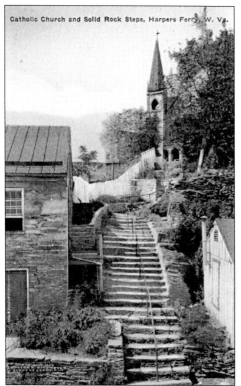

Catholic Church and Solid Rock Steps, Harpers Ferry, W. Va.

With the destruction of war fading into the past, the flowers and plant life around the Stone Steps burst forth with life, making the Stone Steps the subject of the musings of painters and poets. An 18th-century poem reads as follows: "The Stone Steps, anciently carved in virgin rock, A sweet worn town with old world air, A street that climbs on a stone-laid stair, To fableland and green plateau, With the Shenandoah's song below."

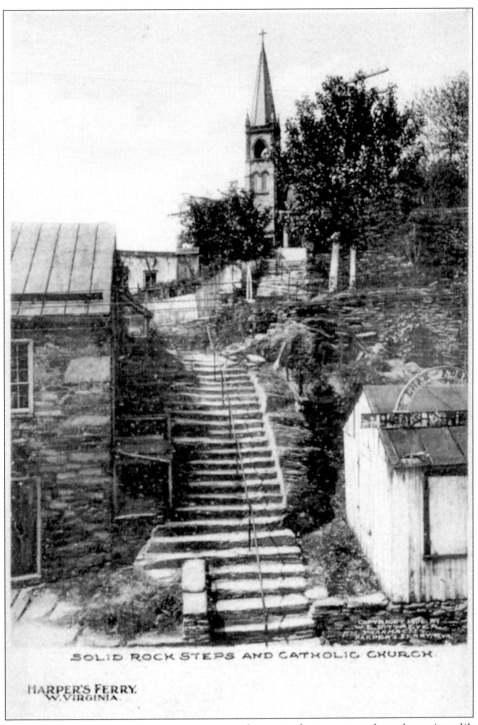

SOLID ROCK STEPS AND CATHOLIC CHURCH.

HARPER'S FERRY.
W. VIRGINIA.

As the climb up the stairs became a very popular route for townspeople and tourists alike, handrails were installed in the steps sometime around 1900. The stairs are still open to the general public today, and the same sturdy iron handrails grace the steps today. The stairs have been in continuous operation for almost two centuries.

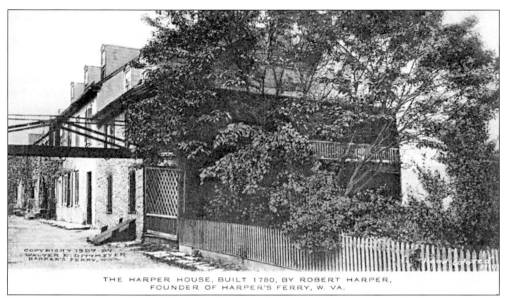

THE HARPER HOUSE, BUILT 1780, BY ROBERT HARPER,
FOUNDER OF HARPER'S FERRY, W. VA.

At the top of the stone steps sits the Harper House, the oldest surviving building in Harpers Ferry, built by the town founder, Robert Harper. Construction on the house began in 1775, but given the lack of able-bodied men to serve as workers during the Revolutionary War, the house was not completed until 1782, the year of Robert Harper's death. From 1782 to 1803, the house served as a tavern and hosted visitors such as Presidents George Washington and Thomas Jefferson.

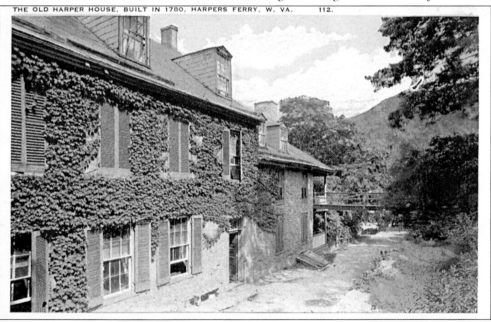

THE OLD HARPER HOUSE, BUILT IN 1780, HARPERS FERRY, W. VA. 112.

Facing towards the back side of the Harper House, this postcard also shows an adjacent building, which was attached to the Harper House in the early 19th century. Today the Harper House stands as part of a row with four separate houses—the Wager House (shown on the card) and the Marmion Tenant Houses (not shown) all added in the early 19th century and joined together. These buildings were used as tenements during the heyday of the U.S. Armory, housing dozens of Armory workers.

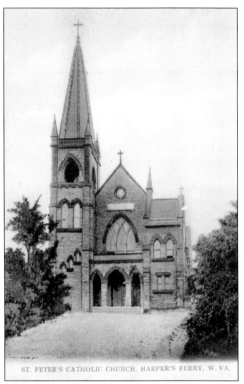

ST. PETER'S CATHOLIC CHURCH. HARPER'S FERRY, W. VA.

St. Peter's Church stands at the apex of the Stone Steps. St. Peter's played an active role in the lives of townspeople since the founding of the church on the banks of the Shenandoah River in 1823. But when the church washed away in a flood around 1828, the church was built on the high ground shown here in 1833. The church was rebuilt on this site in 1896, and the church depicted here is that building.

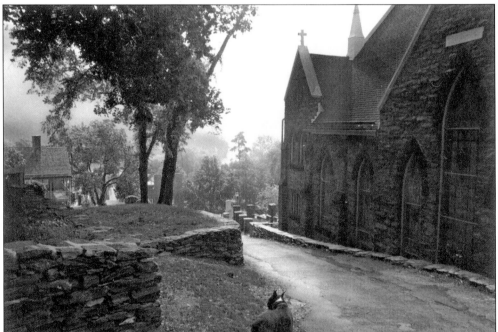

The view from the church has not changed much since the 19th century and affords a beautiful view of the confluence and of the town below, especially in the early-morning hours. A longtime canine resident of Harpers Ferry, Mickey, is enjoying a Saturday morning walk on his way to the Stone Steps and lower town in 1998. The Harper House is visible at the left of this photograph.

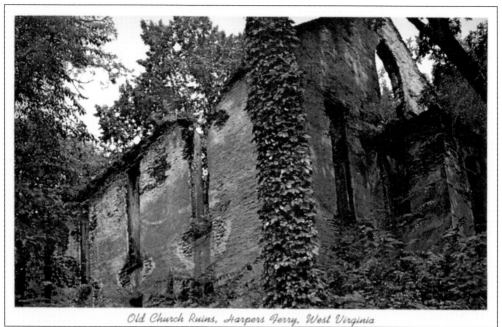

Old Church Ruins, Harpers Ferry, West Virginia

Along the path to Jefferson's Rock, the ruins of St. John's Episcopal Church are visible. First erected in 1852, the church was in shambles after the Civil War, with the inside completely gutted. Parishioners rebuilt the structure in 1882. The building was then sold in 1895 because of poor membership in the congregation. All that remains are the four walls of the old church. The National Park Service engaged in restoration efforts in 2005 in order to stabilize the ruins.

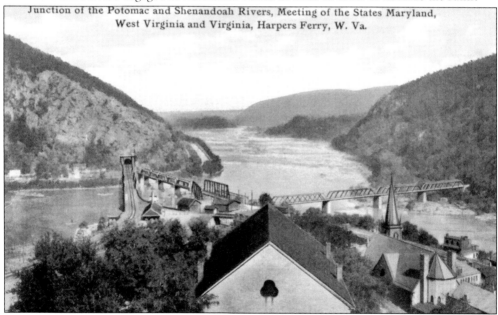

Junction of the Potomac and Shenandoah Rivers, Meeting of the States Maryland, West Virginia and Virginia, Harpers Ferry, W. Va.

Depicted here is the view of the confluence and gap from behind St. John's Episcopal Church, when the building was in a healthier state of existence. The location of the church is about 50 yards up the hill beyond St. Peter's Church at the right of this card. This vantage point was taken from the base of the town cemetery.

Many of the early town residents now reside in the town cemetery, at the apex of the hill and looking down towards lower town. Robert Harper set aside this tract of land for the town cemetery, where he is buried with his family. The view of the gap is spectacular from here. As is illustrated in this photograph, the cemetery is a place where nature consistently reminds visitors that even in death, there is life.

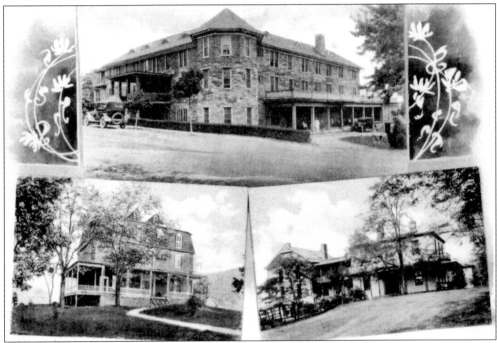

As the tourism trade increased in town, so too did the number of hotels. Pictured here are three of the hotels in the upper town section of Harpers Ferry in the early 20th century. The bottom two buildings depicted here both date to before the Civil War and were government buildings utilized by the U.S. Armory. After the Civil War, the buildings were used by Storer College, including service as dormitories and summer boarding houses and hotels for visitors.

The Hilltop Hotel was first established in 1888 and, situated on a cliff overlooking the confluence of the Shenandoah and Potomac Rivers, afforded visitors a scenic view of the town and rivers. Since 1890, this historic hotel has played host to various presidents, authors, inventors, and other celebrities. Over the years, such guests have included Woodrow Wilson, Mark Twain, Pearl Buck, and Alexander Graham Bell.

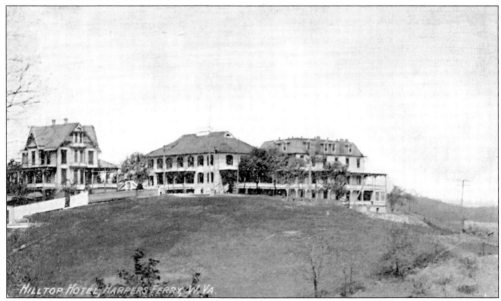

In perhaps one of the oldest postcards of the hotel, the original Hilltop Hotel is depicted along with a neighboring home. The hotel was erected on the location of Magazine Hill and today is the only hotel in town that has been in operation for over 100 years. The original hotel was composed of two largely wooden frame structures.

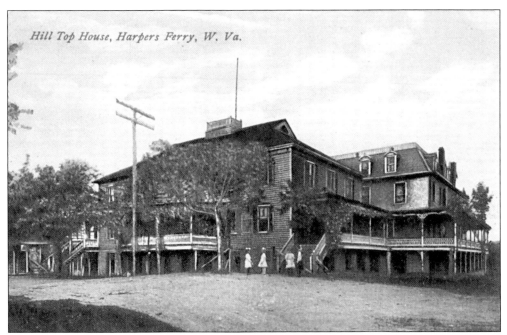

Hill Top House, Harpers Ferry, W. Va.

This early postcard affords a nice side view of the original wood-framed Hilltop House. Note the four small girls in the front in their Sunday best. To this day, the Hilltop Hotel offers an excellent Sunday brunch, and the restaurant affords a view of the Potomac River and the C&O Canal on the other shoreline.

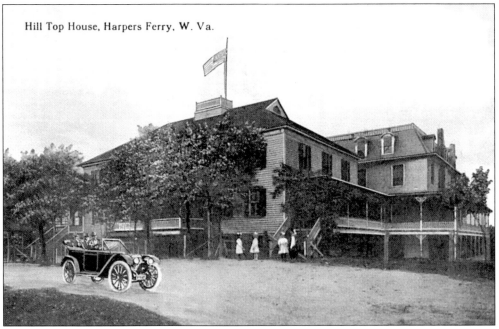

Hill Top House, Harpers Ferry, W. Va.

This postcard shows the identical view of the previous postcard (with the four little girls standing by the front porch). However, the creator of this postcard decided that a few artistic touch-ups were in order. Thus a car was drawn into the image. Also note that the telephone pole was removed and an American flag added to the top of the flagpole.

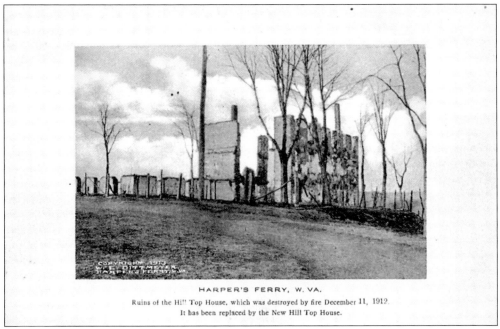

HARPER'S FERRY, W. VA.
Ruins of the Hill Top House, which was destroyed by fire December 11, 1912.
It has been replaced by the New Hill Top House.

On December 11, 1912, the Hilltop Hotel was ravaged by fire and was completely destroyed.

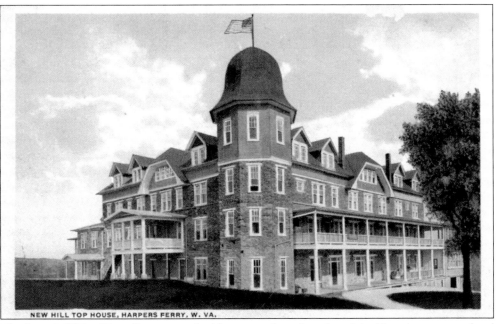

NEW HILL TOP HOUSE, HARPERS FERRY, W. VA.

The "new Hill Top House" was erected with stone and stands on its original location as a grand and imposing structure. One postcard caption of the era read that "it has been damaged by fire several times, but always rebuilt. It is now in perfect state of repair and enjoys considerable patronage."

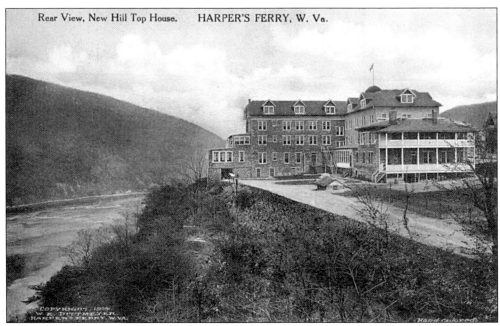

The New York Times reported on April 5, 1959, that "there are happier things in Harpers Ferry, consecrated to history though it is, than the scars of the raid and the ensuing war. There is Hilltop House, for instance, a hotel once frequented by Mark Twain, a President or two, and other celebrities. Artists gather there, not only for its outdoor exhibit in June, but at all times, for the entrancing panorama it overlooks. Tourists, too, find it pleasant."

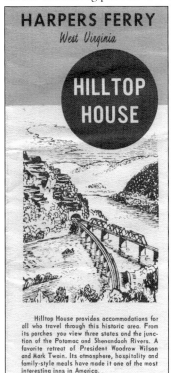

HARPERS FERRY
West Virginia

HILLTOP
HOUSE

Hilltop House provides accommodations for all who travel through this historic area. From its porches you view three states and the junction of the Potomac and Shenandoah Rivers. A favorite retreat of President Woodrow Wilson and Mark Twain. Its atmosphere, hospitality and family-style meals have made it one of the most interesting inns in America.

This brochure dated 1967 lists the Hilltop House rates as "$12.50 per day per person" and includes three meals (including a Special Saturday Night Buffet Feast) and entertainment in its price. Special events listed for 1967 include "old time silent movie night," Mayfest, Bavarian Feast, Oktober Fest, and a production of *The Night of the Student Prince*, among other events for the year.

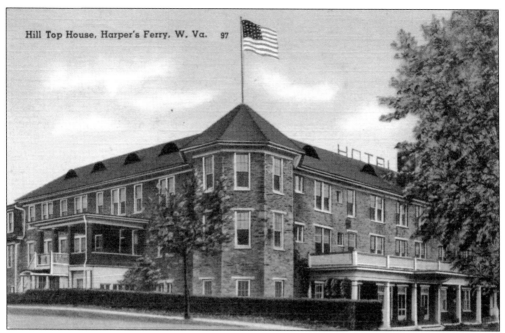

The Hilltop Hotel has long served as a popular resort for those weary from busy lives in Washington, D.C., approximately 60 miles away. The sender of this card wrote that she was "enjoying everything [and] hate to leave this good cool air. . . . We will leave Friday to go back to Washington."

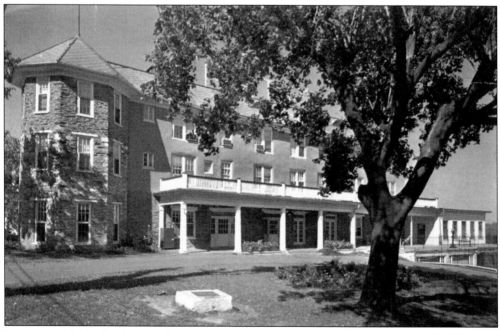

More recently, in April 1998, the sitting president (Bill Clinton) and vice president (Al Gore) visited the hotel and had lunch in the restaurant. The hotel continues to play host to those from around the world who visit Harpers Ferry.

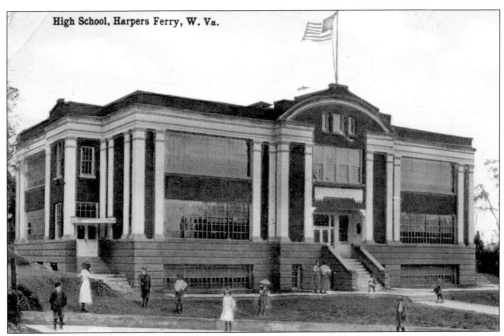

High School, Harpers Ferry, W. Va.

The Old Harpers Ferry High School, also known as the Shipley School, is located on 847 Washington Street and was added to the National Register of Historic Places in 2001. The cornerstone to the building (to the left of the front staircase) reads "erected 1912." Today the National Park Service owns the building and is presently using it for storage, although it has plans in the future to restore this Classical Revival–period school building.

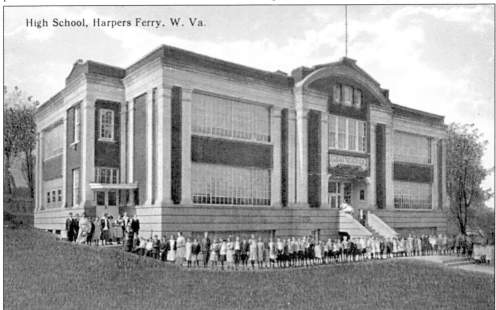

High School, Harpers Ferry. W. Va.

Students are posing for a class or group photograph in the front of the old high school. This postcard was postmarked on May 11, 1916, so the card must depict one of the first groups of students to occupy the building. In 1931, a "new" high school was built in Bolivar, and the old high school served the lower grades, with the older students graduating to the new facility.

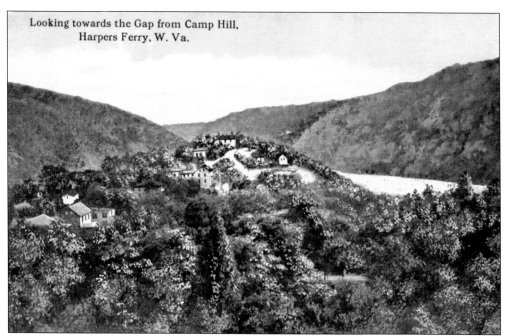

Looking towards the Gap from Camp Hill,
Harpers Ferry, W. Va.

This view was taken from Bolivar and not Camp Hill, as the card erroneously indicates. The adjacent village of Bolivar was originally populated by many of those who worked at the Armory complex in the lower town of Harpers Ferry. In many ways, Bolivar was a suburb of Harpers Ferry in the early 19th century.

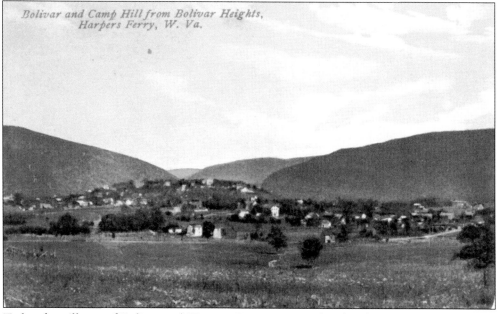

Bolivar and Camp Hill from Bolivar Heights,
Harpers Ferry, W. Va.

Today the villages of Bolivar and Harpers Ferry are considered to be one town by most of the residents, sharing a town hall, post office, and police and fire station, among many other things. The distance from Bolivar Heights to lower town is less than a two-mile walk. Bolivar Heights was the location of the surrender of 12,693 Union soldiers to Gen. Stonewall Jackson and Confederate forces in September 1862.

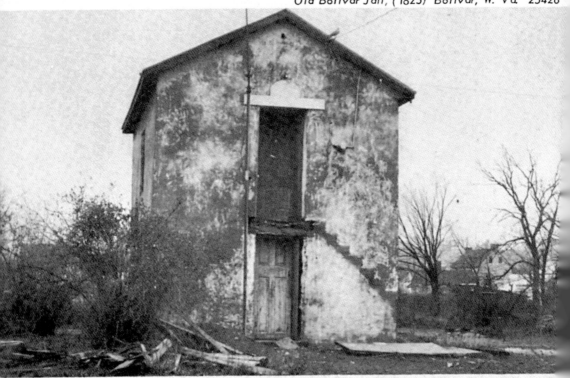

Many very old structures can still be found throughout Bolivar, including a variety of Civil War–era homes. When the old Bolivar Jail was erected in 1825, the town was still called "Mudfort" by local residents and had a population of 270 individuals. Then, on December 29, 1825, the Virginia Assembly gave it the status of being a town and officially named the town after Simon Bolivar.

Seven

STORER COLLEGE

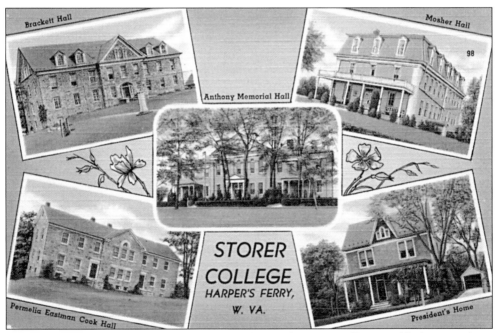

One of the first schools for African Americans in the South, Storer College would educate students from its inception in 1867 through its closing in 1955. While the 1868 charter indicated that it was an "institution of learning for education of youth, without distinction of race or color," it would only serve black students, as the 1872 West Virginia constitution (Article 12, section 8) prohibited racially integrated schools. Of the buildings pictured, only Cook Hall and Anthony Memorial Hall are extant today.

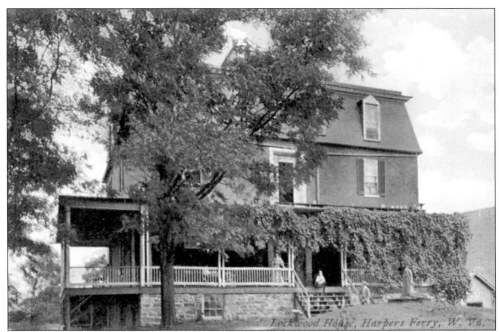

One of Storer College's first buildings was the Lockwood House. The first floor of the Lockwood House was erected by the federal government in 1847–1848 for usage as the armory paymaster's quarters, and a second story was added in 1858. Prior to the Civil War, this impressive structure was referred to by the bland name of Building No. 32. During the Civil War, the house served as headquarters of Union general Henry Lockwood, thereby earning the name of Lockwood House.

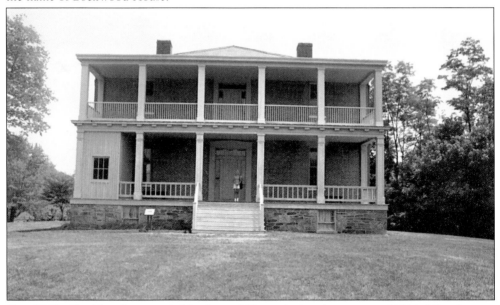

Gen. Philip Sheridan also occupied Lockwood House during the autumn of 1864. After the war, this building was transferred to Storer College and served as one of the college's first buildings, but ownership again reverted to the government in 1960, after the closure of Storer College in 1955.

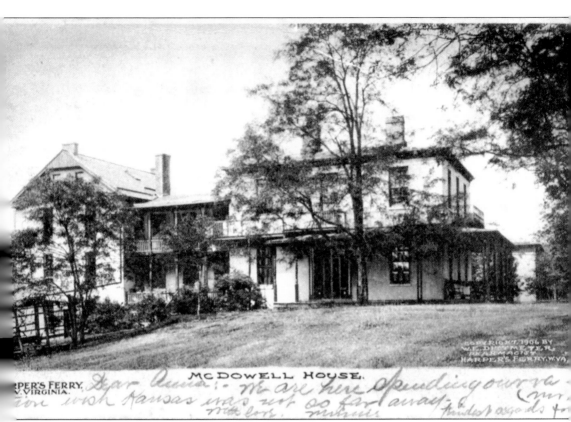

MC DOWELL HOUSE.

PER'S FERRY,
V. VIRGINIA.

[handwritten postcard message, partially illegible]

Located at the intersection of Fillmore and Columbia Streets and adjacent to the Brackett and Lockwood Houses, this house, originally erected in 1858, served as a residence for the U.S. Armory's paymaster's clerk and family. The house was built to the exact specifications of the neighboring Brackett House, and both were erected in 1858 for the federal government. Following its transfer to Storer College in 1869, the house was utilized for a variety of purposes, including service as a dormitory and a summer boarding house. When in service as a hotel, the building was known as the Sparrows Inn and later as Shenandoah Inn. After Storer College closed, the building was transferred to the National Park Service, which today uses the building as the location for its main administrative offices in Harpers Ferry, and it is known as the Morrell House (after Rev. Alexander Morrell, who lived in the house from 1870 to 1881). Local residents at the time may have named the structure after Gen. Irwin McDowell, who commanded the Army of the Potomac during the siege of Harpers Ferry in 1862.

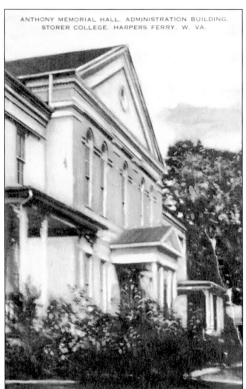

Anthony Memorial Hall served as the flagship building for Storer College from 1869 to 1955. The far right wing of the building was originally erected in 1847–1848 as the residence of the superintendent of the U.S. Armory. Pres. Abraham Lincoln allegedly spent the night in the building in October 1862 when visiting Harpers Ferry. After the Civil War, the building was transferred from the federal government to Storer College, and the building was substantially enlarged in 1882.

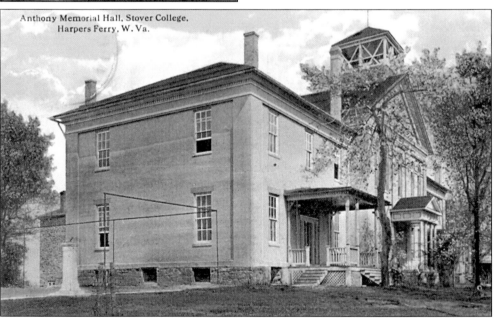

The middle and left wings were added in 1882, and the building was dedicated as Anthony Memorial Hall in recognition of the construction donations of Lewis W. Anthony. The building contained the library, a museum, a chapel, music rooms, laboratories, and administration offices. Note the sundial on a white pedestal. The timepiece is still in place next to Anthony Hall today, keeping time at the exact location it did over 100 years ago.

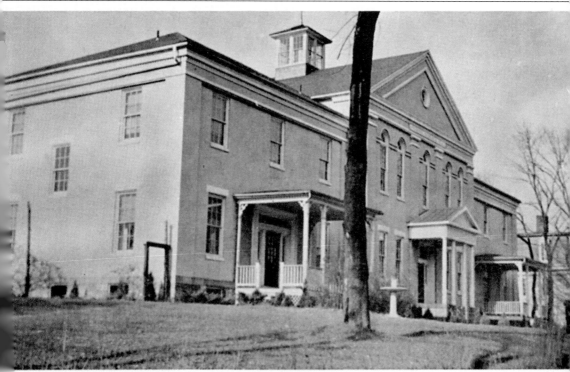

While a fire damaged Anthony Memorial Hall in 1928, the college rebuilt the damaged portions of the building in 1930. Today the building houses the National Park Service Stephen T. Mather Training Center, which provides training and instruction to park service employees. Exhibits on the college are viewable in the Storer College Room located on the first floor of the building. Mosher Hall (pictured at the far right), a dormitory also known as Myrtle Hall, was built in 1878 and housed approximately 60 students and teachers. The construction of the building was financed largely by friends of the college, who, according to the 1924–1925 Storer College Catalogue, "contributed nickels and dimes with which to purchase one or more bricks" towards the completion of the building. The dormitory was torn down in 1962, and a government bomb shelter was built beneath the site. Today the National Park Service uses the bomb shelter for storage and offices, and the entrance is visible to visitors adjacent to the entrance to the parking lot behind Anthony Hall. Mosher Hall is also depicted in the postcard on page 97.

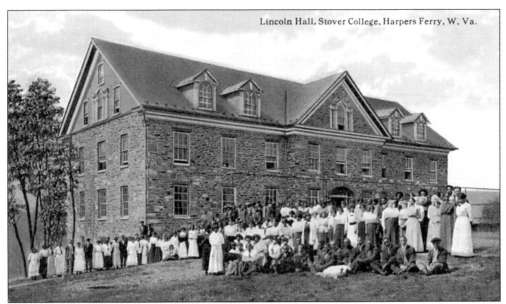

This dormitory overlooked the Shenandoah River and could accommodate up to 100 students. The college catalogue for 1924–1925 heralded the building as state of the art, with a "YWCA room, the Superintendent's flat, the dining room and kitchen, the general reception room, girl's gymnasium and bath rooms" and "steam heated and electric lighted." The building replaced "old Lincoln Hall," which was destroyed by fire on April 12, 1909. It was renamed Brackett Hall in 1938 and was ultimately demolished in 1962.

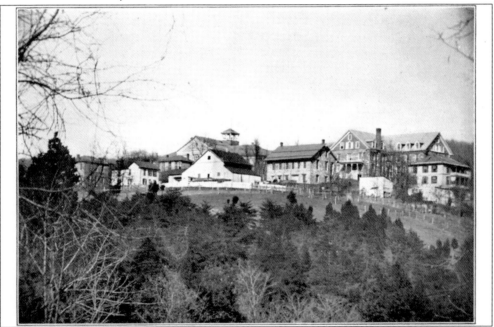

This image, from the 1913–1914 Storer College Catalogue, shows some of the buildings on campus from the ridge above the Shenandoah River. Virtually all of these buildings are now gone, with the notable exception of Anthony Hall, which is clearly identified in this picture by the cupola.

Team of 1952

Depicted here is a very handsome and rugged-looking Storer College football team from 1952. Many football games and scrimmages were played in the field in front of Anthony Hall, which was once a major encampment for Union troops during the Civil War (see page 57). Very little information about the school's football team exists today.

The 1913–1914 Storer College Catalogue advised prospective students that "Storer College presents unusual advantages for study and character building" and that it is "one of the oldest institutions of learning for colored youth in the United States."

~ ALUMNI PAGEANT ~

"Seventy Years of Service"

ON STORER COLLEGE CAMPUS
Harpers Ferry, W. Va.

SATURDAY NIGHT, MAY 29th, 1937
7:30 o'clock P. M.

ADMISSION - - 25 CENTS

This ticket allowed admission for one individual for the Alumni Pageant in celebration of "Seventy Years of Service" and the 70th anniversary of the founding of the college. This card was found preserved between the pages of a first-edition copy of *Uncle Tom's Cabin* owned by a Harpers Ferry resident during this time period. In 1955, Storer College would close its doors, just 12 years shy of its centennial. In the college's 88 years, it played a prominent role in the town and in the life of its students. All told, the college produced graduates who went on to careers in teaching, law, medicine, music, and politics. The last graduating class celebrated its 50th anniversary graduation reunion in 2005.

Eight

TRANSPORTATION IN HARPERS FERRY

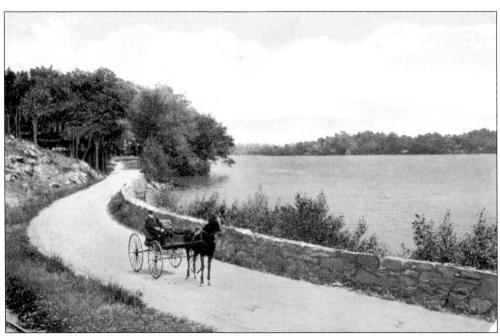

Harpers Ferry has been witness to all forms of transportation, from horses and river ferries to automobiles and airplanes. In addition, Harpers Ferry was a major hub on the Baltimore and Ohio (B&O) Railroad, as well as the Chesapeake and Ohio (C&O) Canal, as both raced to be the first to reach Harpers Ferry in the 1830s.

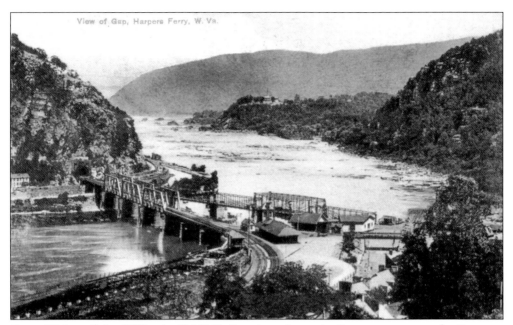

From 1834 until the 1890s, the B&O Railroad ran its tracks from town, across the Potomac River, and around the base of Maryland Heights (to the right on this postcard). However, to the right of Maryland Heights, the railroad competed with the C&O Canal and an old country road/turnpike (both visible on this image) for space between the rocks of Maryland Heights and the Potomac River.

Because of the scarcity of space, the B&O Railroad burrowed an 815-foot tunnel through the base of Maryland Heights in 1893. Extensions were added to the tunnel in 1896—the date carved in stone above the tunnel on this card. Today the tunnel reads "1931 Harpers Ferry" to connote expansions to the tunnel made in 1931.

In 1892–1893, along with the creation of the tunnel, the B&O Railroad purchased the rights to place train tracks over the remnants of the Armory grounds and to build a new steel bridge in order to eliminate a sharp curve in the tracks. On April 12, 1894, the new bridge, tunnel, and tracks officially opened, and this postcard captures how the new bridge and tunnel looked around 1896. Visitors today can walk across the historical 1894 B&O Bridge.

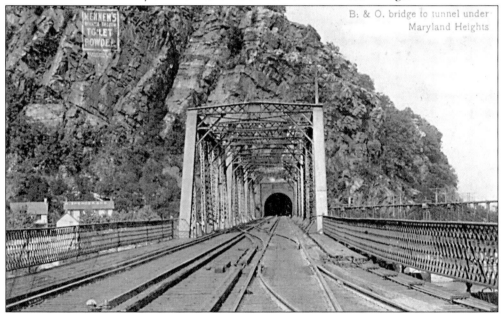

B: & O. bridge to tunnel under Maryland Heights

This W. L. Erwin postcard was published in 1908 and shows the B&O Bridge and Tunnel. Note the sign painted on the side of Maryland Heights (above left of the bridge and directly above houses). This sign, painted in 1896, is absent from the previous, older postcard. The sign reads "Mennen's Borate Talcum Toilet Powder." The local legend of this sign is described on the next page.

Local legend is that the sign was painted by a German immigrant, who was paid $45 to scale down the side of the Heights and paint the advertisement on the perpendicular rocks. It allegedly took the worker six weeks to paint the advertisement, and he mixed his paint with goat's milk. It was advertising money well spent, as the sign is still visible today, despite multiple attempts to eradicate the sign—including sandblasting.

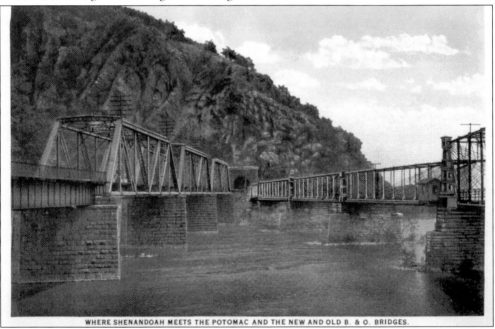

WHERE SHENANDOAH MEETS THE POTOMAC AND THE NEW AND OLD B. & O. BRIDGES.

The bridge to the left is the "new" 1894 B&O Railroad Bridge, and the bridge to the right was the locally well-known Bollman Bridge, which was built in a style similar to the Brooklyn Bridge in New York. The Bollman Bridge was destroyed in the flood of 1936, and parts of the bridge are still visible in the Potomac River. Only the piers of the bridge remain in place today.

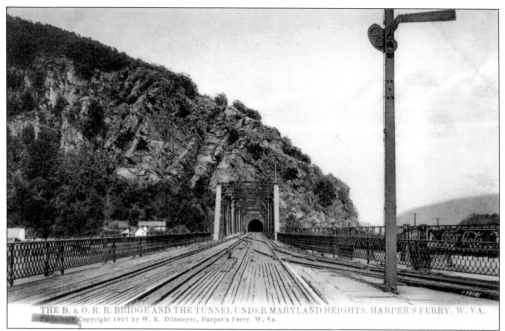

THE B. & O. R. R. BRIDGE AND THE TUNNEL UNDER MARYLAND HEIGHTS. HARPER'S FERRY, W. VA.
Copyright 1907 by W. E. Dittmeyer, Harper's Ferry W. Va.

The two houses to the left of the bridge are the infamous Salty Dog Saloon and the C&O Canal Lockkeeper's House for Lock Number 31. The Salty Dog Saloon was owned by an A. Spencer, and he also had a Dime Museum in Harpers Ferry, about which, according to an early advertisement, "traveling salesmen, tourists, and strangers generally have expressed their surprise upon viewing such an immense aggregation" of relics. Note also the "Drink Coca-Cola" sign.

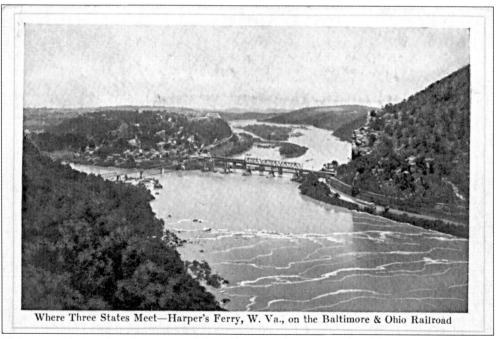

Where Three States Meet—Harper's Ferry, W. Va., on the Baltimore & Ohio Railroad

This postcard, showing the town and the railroad tracks, was produced by the B&O Railroad for its customers. A canal boat is visible traveling along the C&O Canal.

Issued April 26, 1959

SYSTEM TIME TABLES

Baltimore & Ohio
RAILROAD

All schedules in this folder are printed in STANDARD TIME

(Daylight Time is one hour later than Standard)

LINKING 13 GREAT STATES
B&O
WITH THE NATION

PLEASE KEEP FOR REFERENCE

In its heyday, the B&O Railroad had multiple trains passing through Harpers Ferry each day, even as late as 1959. Today local commuters can still "ride the rails" from Harpers Ferry down to Washington, D.C., each day, courtesy of the Maryland commuter trains and Amtrak.

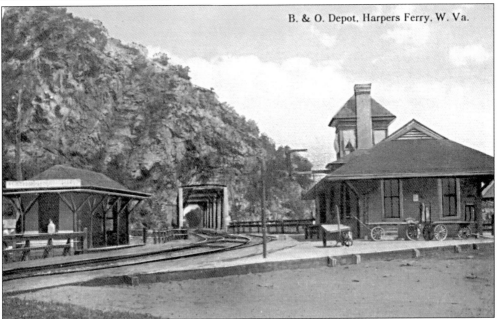

B. & O. Depot, Harpers Ferry, W. Va.

The new B&O depot, opened in 1894, was erected on top of approximately 20 feet of landfill that covered the old Armory grounds (including the original site of John Brown's Fort). In 1931, the depot station was moved back approximately 100 feet (to its present location). The tower has also been removed.

In 2004–2005, the National Park Service acquired ownership of the station from CSX Railroad and in 2005 began restoring the train depot to its original 1894 appearance, including a reconstruction of the old depot tower. Pictured here in January 2006, the depot was temporarily raised off its foundation for work.

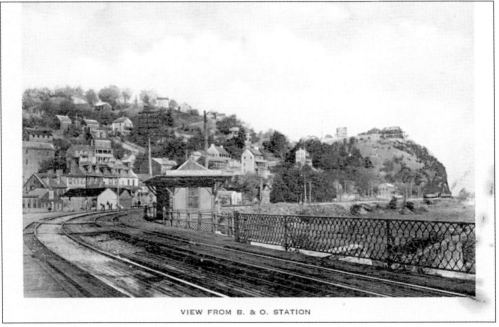

VIEW FROM B. & O. STATION

This image, from a souvenir booklet of Harpers Ferry produced by Walter Dittmeyer in the early 20th century, shows the view from the B&O Railroad Bridge looking back towards the town. If one looks closely, one can make out the caboose and last car of a train rounding the base of the hill.

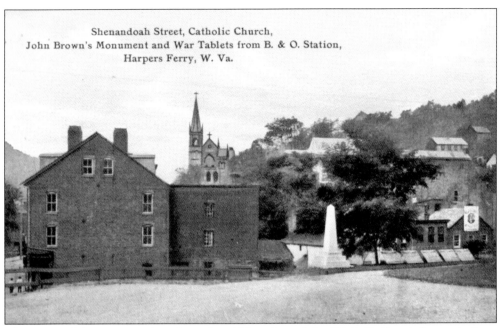

Shenandoah Street, Catholic Church,
John Brown's Monument and War Tablets from B. & O. Station,
Harpers Ferry, W. Va.

This postcard image was taken from the old location of the B&O Railroad depot platform looking back towards the town. The large brick building was Dittmeyer's Pharmacy, and Walter Dittmeyer produced a great amount of the town's early souvenir items, such as postcards and booklets commemorating the town. Today the building houses the John Brown Museum and administrative park service offices on the upper floors.

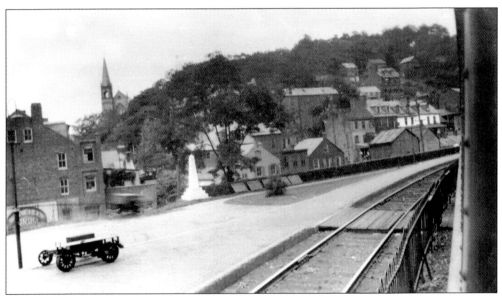

This previously unpublished photograph was taken in July 1920 from onboard a B&O Railroad passenger train. This image offers an everyday, unpolished view of the town in 1920. Note the railroad handcart. Above the handcart, the "Dittmeyer's Drug Store" sign is faintly visible.

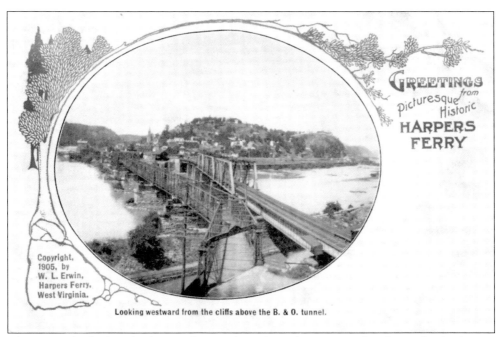

Looking westward from the cliffs above the B. & O. tunnel.

This postcard is looking back towards town from above the B&O Railroad tunnel. The distinct ironwork of the Bollman Bridge is visible.

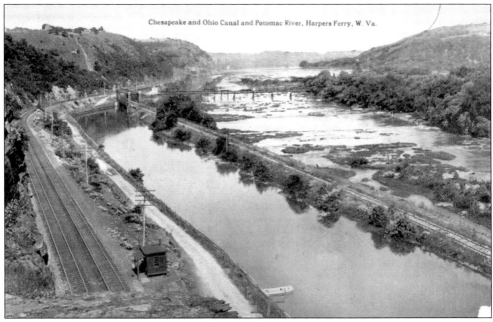

Chesapeake and Ohio Canal and Potomac River, Harpers Ferry, W. Va.

The title of this card erroneously indicates that it depicts the Chesapeake and Ohio Canal, while the postcard actually depicts the Armory Canal on the opposite side of the Potomac River. This canal, or headrace, funneled water from the Potomac River down to the U.S. Armory Musket Factory, where the water powered the waterwheels and turbines for the factories.

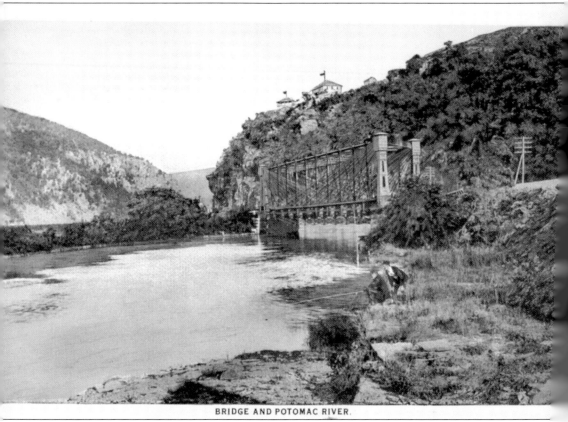

BRIDGE AND POTOMAC RIVER.

At the end of the Armory Canal, the government power canal bridge (called the Bollman Railroad Span) was erected in 1866. The bridge was built in the same style as the main Bollman Bridge. Note the two men fishing along the banks of the Potomac River below the bridge. Just beyond the bridge, and a short distance upstream from Harpers Ferry, was Byrnes Island, which became a major tourist attraction in the late 19th century.

Island Park and Bridge, Harpers Ferry, W. Va.

In 1878, the Baltimore and Ohio Railroad bought Byrnes Island and opened an amusement park called Island Park. This pedestrian bridge was the chief mode of entering and exiting the amusement park, which, according to Harpers Ferry mayor Gilbert E. Perry in 1957, "was every bit as gay as Coney Island," and "on weekends and holidays as many as 28 excursion trains a day brought picnickers, bowling clubs, singing societies, and honeymooners up from the city."

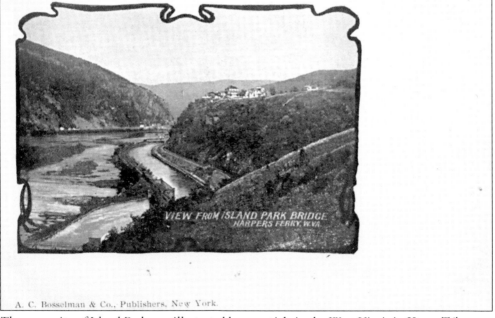

The enormity of Island Park was illustrated by an article in the West Virginia *Keyser Tribune* on June 26, 1914, which indicated that "the 33rd annual outing of the employees of the entire B&O system east of Parkersburg and Pittsburgh will be held July 30 at Island Park, Harpers Ferry and it is expected that *fully five thousand persons* will be in attendance."

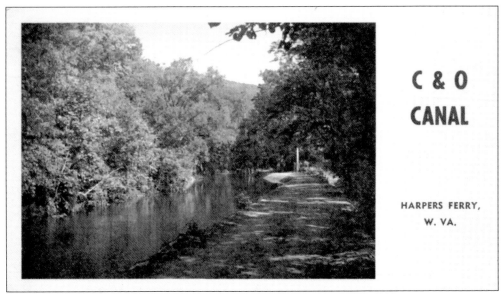

The C&O Canal reached Harpers Ferry in 1833, one year before the B&O Railroad reached the town. However, the B&O Railroad ultimately outlasted the canal, the canal ceasing operations in 1924 after suffering damage from repeated floods.

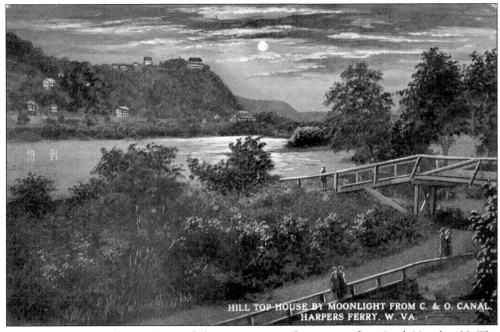

This postcard depicts the C&O Canal about a quarter-mile upstream from Lock Number 33. The building across the Potomac River and farthest to the right is the Harpers Ferry Power Plant, which provided electricity to the town from 1925 to 1991, when the power plant shut down.

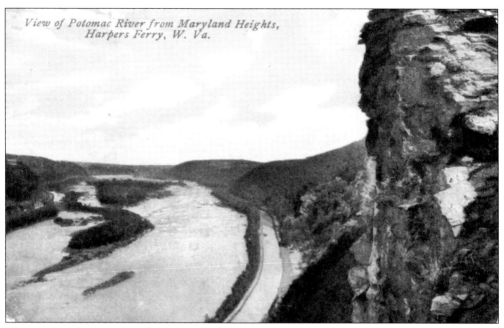

View of Potomac River from Maryland Heights, Harpers Ferry, W. Va.

The terrain along the canal was mountainous upon arriving at Harpers Ferry. As one person described in 1859: "We were now nearing the Blue Ridge Mountains and the celebrated Harper's Ferry notch and as we entered it, the mountain on the north (Maryland Heights) . . . crowded more and more on the canal until it had to be built in the edge of the river. Opposite this mountain is the town of Harper's Ferry, built on two slopes of a very steep hill one house rising above the other in terraces."

Chesapeake and Ohio Canal

Today the C&O Canal is preserved by the National Park Service, and lovers of nature can enjoy hikes along the canal from its starting point at Georgetown, D.C., to its end at Cumberland, Maryland, and certainly at places like Harpers Ferry in between.

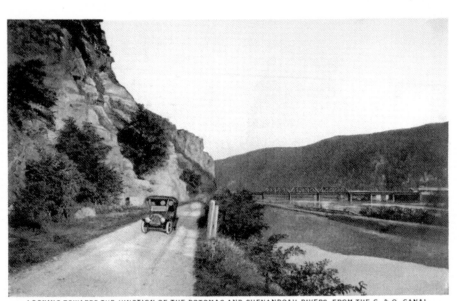

LOOKING TOWARDS THE JUNCTION OF THE POTOMAC AND SHENANDOAH RIVERS, FROM THE C. & O. CANAL.

In time, the transportation offered by both the C&O Canal and the B&O Railroad would become outdated. One could travel to Washington, D.C., in a matter of hours, instead of the number of days it would take to make such a trip along the C&O Canal. This road, now a double-lane paved road, is still utilized today.

While it once took hours to travel the eight to nine miles from Harpers Ferry to neighboring Charles Town (seat of Jefferson County government and site of the John Brown trial, among other things), the trip can now be done in less than 10 minutes by automobile. This 1913 postcard promotes the fine roads.

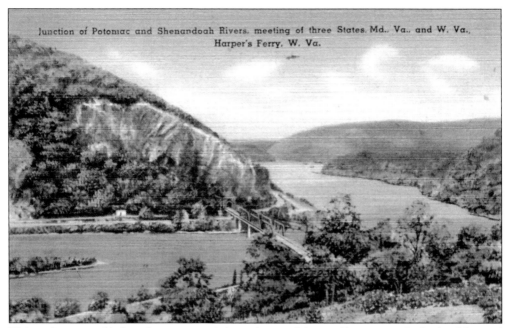

Junction of Potomac and Shenandoah Rivers, meeting of three States. Md., Va., and W. Va., Harper's Ferry. W. Va.

This early postcard is based upon an artist's rendition of the confluence. As the back of the card describes, "the merry Potomac and the laughing Shenandoah wed and rush on to the sea. At the base of Maryland Heights one can distinguish three methods of transportation—highway, railroad, canal."

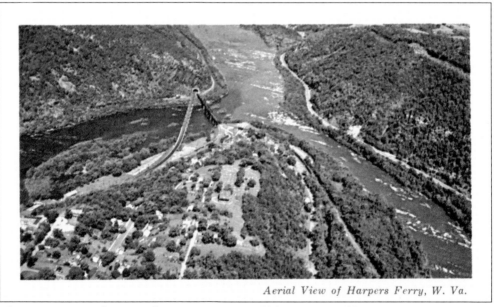

Aerial View of Harpers Ferry, W. Va.

Also, in time, aerial views of Harpers Ferry would become possible. It is interesting to note that when John Brown came to town in July 1859, he climbed to the top of Maryland Heights in order to survey the town and its structures. Today one can survey the town by helicopter or airplane.

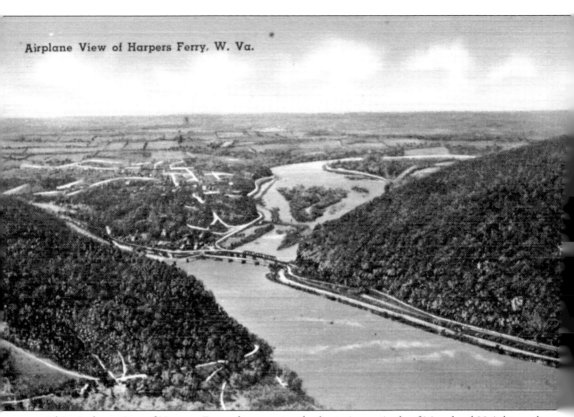

Airplane View of Harpers Ferry, W. Va.

This airplane view of Harpers Ferry shows not only the twin sentinels of Maryland Heights and Loudoun Heights but also the fertile land of Jefferson County, West Virginia, beyond the historical town limits. Jefferson County has always been well known for its agricultural character.

Nine

TRANSITION TO A
NATIONAL PARK

For much of the town's existence, its history was not preserved by the federal government or the National Park Service but rather by local citizens. For instance, town poet and historian Joseph Barry chronicled much of the town's early history in his book entitled *The Strange Story of Harper's Ferry*, published in 1903. This book was based upon his earlier book, *The Annals of Harpers Ferry*, which he wrote under the pen name Josephus Junior in 1869. Other early residents of the area, like Dittmeyer and Erwin, produced many of the postcards that grace this book—thereby preserving early views of the town that would otherwise be lost to history. However, the federal government would play an important role in preserving the town's history within the last half century.

HARPERS FERRY
NATIONAL MONUMENT

Dr. Henry McDonald, president and professor at Storer College, and Congressman Jennings Randolph first proposed making the town of Harpers Ferry a national park in 1936. After many public meetings and feasibility studies, Pres. Franklin Roosevelt signed into law the legislation creating the Harpers Ferry National Monument on June 30, 1944. However, Congress did not appropriate any funds to acquire land, and the law only authorized the Monument Association to accept up to 1,500 acres of donated land. Thus local leaders like McDonald and Randolph had to continue their efforts to raise funds for land acquisition. Regional papers like the *Washington Post* and *Baltimore American Life* promoted the park. For instance, on July 17, 1955, in a pull-out section of the *Baltimore American Life*, the town's history was discussed, with several large photographs and the headline "Harpers Ferry: Another Williamsburg?"

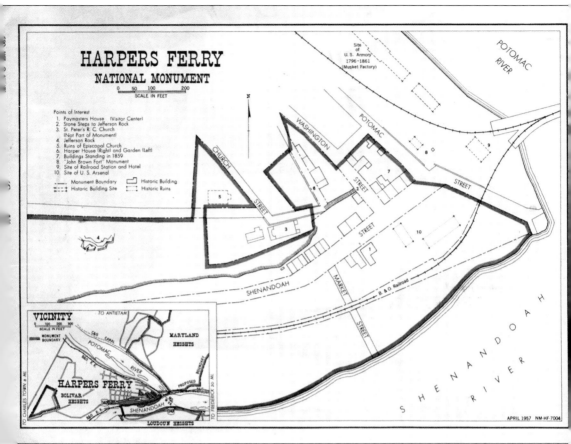

On March 12, 1951, West Virginia appropriated $350,000 for the acquisition of 514 acres of land in lower town, as well as portions of Loudoun Heights and Bolivar Heights. In 1960, an additional 30 acres of land from the old Storer College campus was donated to the park, and in 1963, Maryland donated 763 acres of land on Maryland Heights. Further and very importantly, in 1963, Congress changed Harpers Ferry from a National Monument to a National Historical Park. According to the newly elected U.S. Senator Randolph, using the term monument was never correct for Harpers Ferry, as it did "not convey the vast scope of history and natural grandeur which are to be found at Harpers Ferry." Thus, by the 1970s, the town's transition from an antiquated town to a major national park was largely complete. Since that time, there have been additional expansions of land, most recently in 2002. Today the park is in excess of 3,700 acres. This map depicts the boundaries of the Harpers Ferry National Monument after its acquisition of the first several hundred acres of land.

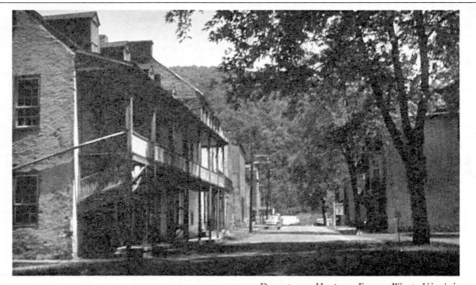

Downtown Harpers Ferry, West Virginia

When the lower town was first transformed into a national park, many of the buildings were dilapidated and had been neglected for decades. Methodically the park service went about stabilizing and restoring the buildings. In the left foreground is the John G. Wilson Building (erected in 1825–1826), which was described in 1829 by Armory superintendent James Stubblefield as "stone, rough cast, used as dwelling and store house." Today the park service bookstore operates out of the Wilson Building.

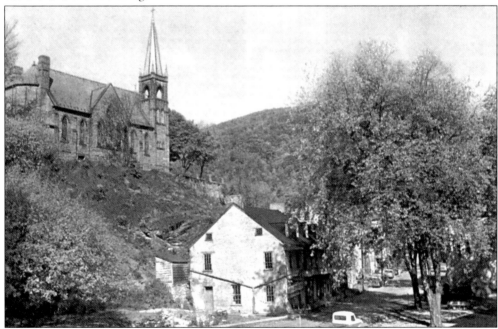

Automobile noise and traffic presented an early problem for the park. As one park superintendent described in the 1970s, congestion and noise by automobiles was "destroying the park and eliminating any meaningful visitor experience." Note the multiple vehicles parked along the curb on Shenandoah Street.

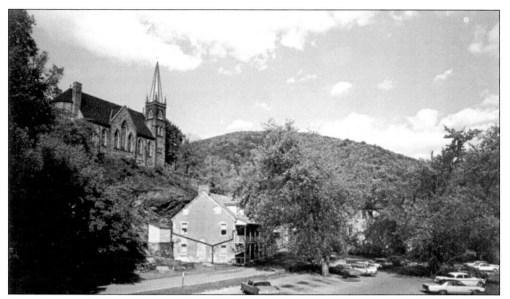

Even when vehicles were not parked directly on Shenandoah Street, they were parked just off the road and within eyesight. In 1990, a new 1,000-vehicle parking lot and visitor center was built approximately two miles west of lower town. Visitors can now park their vehicles at the Visitor's Center and take one of the park's shuttle buses to lower town. While vehicular noise and traffic is largely minimized today, loud motorcycles passing through town still hinder the historical experience for many.

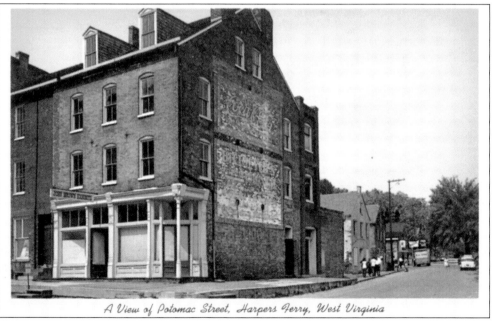

A View of Potomac Street, Harpers Ferry, West Virginia

The building on the corner of Potomac and Shenandoah Streets was Walter Dittmeyer's pharmacy in the early 20th century. The faded painted signs on the side of the building are for Coca-Cola and Dittmeyer's Drug Store. The building was originally built in 1837–1838 and served as a tavern and eating house. Today the building houses the John Brown Museum as well as the National Park Service's Museum and Archives offices.

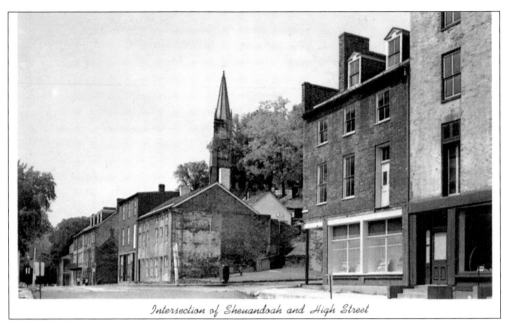

Intersection of Shenandoah and High Street

The two houses on the right side of the intersection of Shenandoah and High Street are the Ann C. Stephenson Building (second building from left, erected 1840–1845) and the William Anderson Building (at right, erected 1838–1839). The Ann C. Stephenson Building is named after an 82-year-old widow who lived in the house at the time of John Brown's Raid in 1859, and one of the raid victims (Thomas Boerly) was mortally wounded at the back left corner of the house.

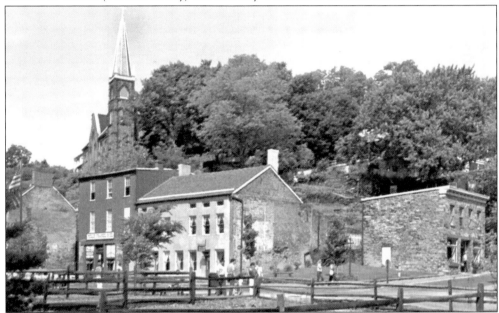

At the right is one of the oldest structures in the lower town of Harpers Ferry, called the John T. Rieley Building (erected 1804–1813). It housed an apothecary shop under four separate owners from 1820 to 1853, including an apothecary shop under the management of Dr. Joseph G. Hays (1831–1850). After the death of Dr. Hays in the cholera epidemic of 1850, the building housed John T. Rieley's Boot and Shoe Manufactory.

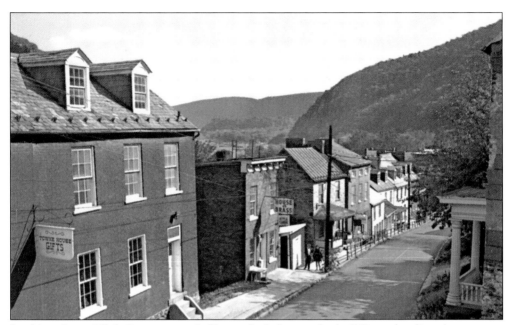

Looking down High Street towards Shenandoah Street, the buildings that line the street to the left are all privately owned residences, shops, restaurants, and antique stores. This postcard dates to the 1960s.

Three generations of a family pause to contemplate the flood lines marked on the side of building in lower town in 1999, with the buildings of Shenandoah Street in the background. It was the first visit to Harpers Ferry for then-87-year-old Joseph Koczwara; his daughter Jeannie Senediak; his grandson, John Senediak; and his grandson's wife, Hillary. Millions of visitors like these individuals flock to Harpers Ferry each year to contemplate the rich history of time and place.

www.arcadiapublishing.com

Discover books about the town where you grew up, the cities where your friends and families live, the town where your parents met, or even that retirement spot you've been dreaming about. Our Web site provides history lovers with exclusive deals, advanced notification about new titles, e-mail alerts of author events, and much more.

MADE IN THE

Arcadia Publishing, the leading local history publisher in the United States, is committed to making history accessible and meaningful through publishing books that celebrate and preserve the heritage of America's people and places. Consistent with our mission to preserve history on a local level, this book was printed in South Carolina on American-made paper and manufactured entirely in the United States.

This book carries the accredited Forest Stewardship Council (FSC) label and is printed on 100 percent FSC-certified paper. Products carrying the FSC label are independently certified to assure consumers that they come from forests that are managed to meet the social, economic, and ecological needs of present and future generations.

FSC

Mixed Sources
Product group from well-managed forests and other controlled sources

Cert no. SW-COC-001530
www.fsc.org
© 1996 Forest Stewardship Council

Find Your Place in History.

Harpers Ferry, West Virginia

Harpers Ferry, located at the confluence of the beautiful Shenandoah and Potomac Rivers, offers visitors a breathtaking view described by Thomas Jefferson as a "scene worth a voyage across the Atlantic." From George Washington's 1796 establishment of the federal armory, through John Brown's 1859 raid to foment slave rebellion and Civil War battles, and to one of the first successful colleges for African Americans, Harpers Ferry has played a significant role in America's history. Hundreds of vintage postcards, many of which are very scarce today, depict this history, the various scenic views and buildings in town, and the daily lives of townspeople over the last century.

After visiting Harpers Ferry and falling in love with its history and beauty, Prof. James A. Beckman and his wife, Maria, (along with their beloved dog, Mickey) moved to the town in 1997. Though he is now tenured professor at the University of Tampa, they continue to spend time at their Harpers Ferry home. Beckman has lectured and published articles on the town's history and served as an artist-in-residence for the Harpers Ferry Historical Park in 2001.

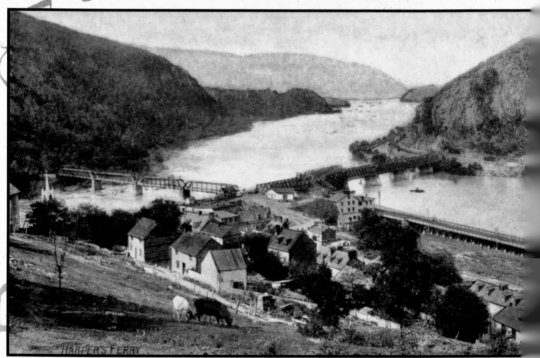

HARPER'S FERRY

ISBN-13 978-0-7385-4291-1 $21.99
ISBN-10 0-7385-4291-1

52199

9 780738 542911

MADE IN THE
USA

FSC
Mixed Sources
Product group from well-managed
forests and other controlled sources
Cert no. SW-COC-001530
www.fsc.org
© 1996 Forest Stewardship Council

www.arcadiapublishing.com

IMAGES *of America*

LONGVIEW

NUTTY NARROWS BRIDGE

I'm Nuts about....

Nutty Narrows
Longview
WASHINGTON

*Dennis P. Weber with
Karen Dennis and Sue Maxey*